CW00553559

YORKSHIRE
PEOPLE AT WORK

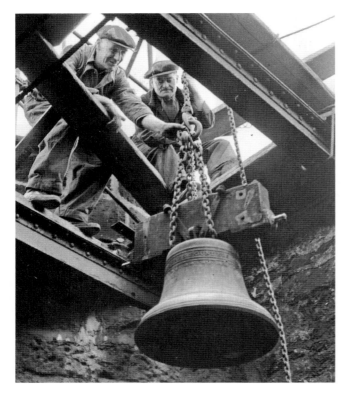

Guiseley parish church's eight bells were taken down for recasting in May 1946. The structure of the belfry was such that they had to be hauled out of the top, as seen here, and lowered down the outside.

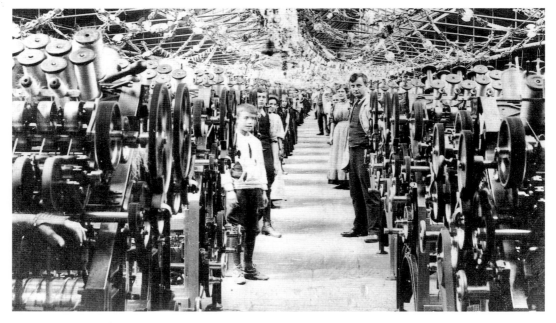

An interior view of Salts Mill at the turn of the nineteenth century. Note the cramped conditions and how young some of the employees appear.

YORKSHIRE
PEOPLE AT WORK

FROM THE **YORKSHIRE POST** PICTURE ARCHIVES

PETER TUFFREY

AMBERLEY

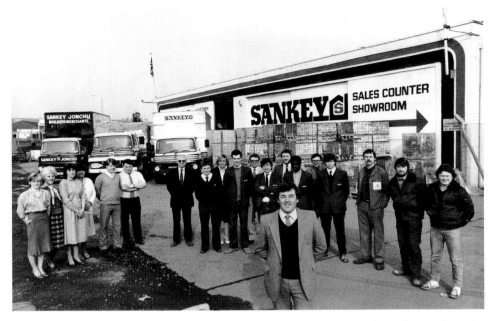

Mr Geoffrey Kellett in the foreground with his staff outside the Whitehall Road, Leeds, premises of Sankeys in April 1985.

First published 2012

Amberley Publishing
The Hill, Stroud
Gloucestershire, GL5 4EP

www.amberleybooks.com

Copyright © Peter Tuffrey 2012

The right of Peter Tuffrey to be identified as the Author
of this work has been asserted in accordance with the
Copyrights, Designs and Patents Act 1988.

All rights reserved. No part of this book may be reprinted
or reproduced or utilised in any form or by any electronic,
mechanical or other means, now known or hereafter invented,
including photocopying and recording, or in any information
storage or retrieval system, without the permission in writing
from the Publishers.

British Library Cataloguing in Publication Data.
A catalogue record for this book is available from the British Library.

ISBN 978 1 4456 0515 9

Typeset in 10pt on 12pt Sabon.
Typesetting and Origination by Amberley Publishing.
Printed in the UK.

Contents

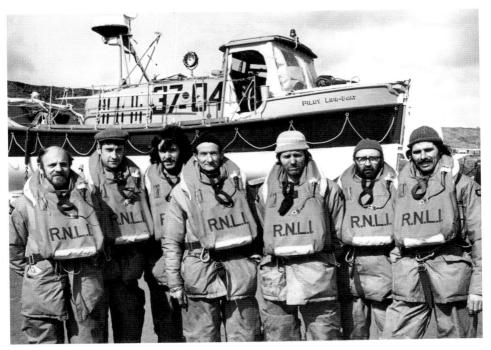

Filey Lifeboat crew in April 1983. They are, from left to right, John Whitehead, Colin Huddington, Richard Hodgson, Frank Jenkinson, Harry Jenkinson, Graham Taylor, and Bruce Jenkinson.

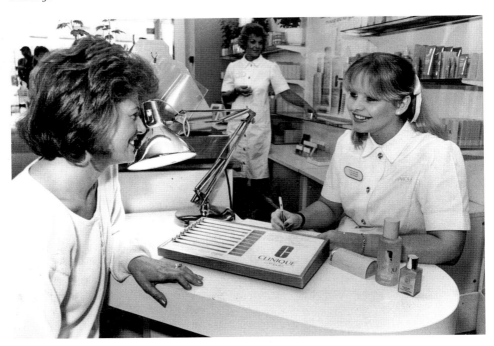

Schofield department store's beauty department in Leeds, taken during August 1988.

Introduction

I first had the idea for this book whilst trawling through the *Yorkshire Post* photographic archives for images to include in a previous title, *Yorkshire People and Railways*. Noticing individuals of varying ages, class, colour and gender, working in a group or on their own, in a marvellous variety of weird, wonderful, dangerous or purely mundane tasks, I decided there was definitely scope for a book.

So another long trawl ensued, as I gathered pictures for this new idea. What were the criteria? First it would be an idea to include jobs that were typically Yorkshire-related – e.g. fishing, textiles, steel and railways to mention just a few. Secondly the book must include a fair balance of men and women going about their daily tasks. Thirdly I did not want to be bound by a single period. In fact some pictures are quite old while others were taken in recent months. Of course the photographs had to be well composed and have some artistic flair. As they were all taken for publication in the *Yorkshire Post* (YP) or *Yorkshire Evening Post* (YEP), none of those selected could fail the test. Of course it was very convenient to use 'professional' pictures because they are cleverly composed to instantly reveal the person's job.

So with these certain criteria in mind I nestled comfortably in the *Yorkshire Post* library, hemmed in by racks upon racks of boxes of pictures containing images of cities, towns and villages of the North of England. There were, of course, other boxes holding pictures of specific subjects, such as industry, mining, fishing, and bridges.

It quickly became abundantly obvious I would be deviating considerably from my initial thoughts. First I found that both newspapers had pet subjects they liked to feature, such as archaeology, the arts, church restoration, markets and engineering work. Out of this batch I chose pictures of archaeologists on Thorne Moors, artist Joe Scarbough, sculptor Graham Ibbeson, restoration work on Beverley Minster, as well as Leeds market and the building of the Humber Bridge. There were a vast number of pictures taken of people at work for use in commercial advertising features or to commemorate a company anniversary and some of these are included.

I also quickly noticed that the range of jobs carried out by Yorkshire people was immense, and discovering the unexpected is what has been so pleasurable in compiling the book. In total I had around 1,200 pictures to choose from, and whittled this number down to around 225.

It was fascinating to learn about the exploits of the egg collectors at Bempton Cliffs, not to mention the dangers to which they put themselves. Of course their activities are illegal today, and rightly so most would agree. I was also interested to learn that operatives at the Fylingdales military installation would be the first to know if the Russians launched a nuclear attack on the West.

It is fascinating to note the professions people opt to devote their whole lives to, and I suppose in choosing these pictures I have subconsciously selected a number of jobs that I marvel at and could not do myself. I'm sure most people given the task of compiling their own selection would react in the same way. Personally, I marvel at the lady fire eater, or indeed the firemen themselves, or the stuntmen.

I am pleased that there is a reasonable balance of pictures showing both men and women at work. It is abundantly clear that some jobs, once considered male strongholds, are now carried out by women. And why not? Females driving trains and undertaking gamekeeper duties illustrate this perfectly.

The more up-to-date pictures were drawn from the *Yorkshire Post*'s digital collection and I am grateful for the assistance of the Digital Photographic Archivist, David Clay, who made this possible and offered some interesting suggestions concerning pictures which were permitted to be included from this source. Paul Bolton of the *Yorkshire Post* also gave useful advice about the overall content of the book.

In many cases, when there was not enough information attached to a photograph I headed for the bound volumes section and it is fortunate that newspapers extending back to the eighteenth century are still held there. Once I had found the article associated with the picture I was then able to write a caption.

What did I leave out, some people may be pondering. 'Quite a lot' is the answer and maybe there is more than enough for another volume. That remains to be seen. In the meantime I hope you enjoy this first selection.

Peter Tuffrey

Acknowledgements

I am grateful for the assistance of the following people: Paul Bolton, Peter Charlton, David Clay, Keith Hampshire, Hugh Parkin.

Special thanks are due to my son Tristram Tuffrey, who provided valuable support behind the scenes.

All photographs copyright Yorkshire Post Newspapers. View and buy the full range of pictures in this book by visiting www.yorkshirepost.co.uk or contact our photosales department on 0113 238 8360, giving the page number and full details of the picture.

One

Abattoirs to Bridges

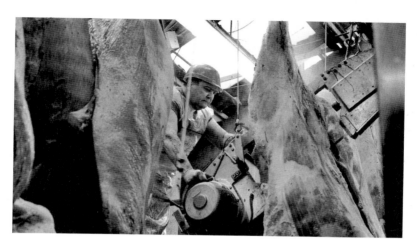

Abattoirs

Interior views of meat wholesaler John Penny & Sons' abattoir in Rawdon, Leeds. John told the *YP* of 11 November 2010 that he was becoming increasingly frustrated with battling against myths and misconceptions, so much so that he was one of the few in the industry happy to open the abattoir doors to anyone who wanted to see inside: 'I'm as soft as a brush when it comes to animals, but we eat meat and animals have to be killed. It's in our interest to treat our animals humanely and here we have nothing to hide and a lot to be proud of. As a country, we've become disconnected from the food we eat. People should know what goes into rearing the meat they buy. They should know how it's killed and if they come here I guarantee it won't put them off. In fact it will make them value the quality of meat they put into their mouths.'

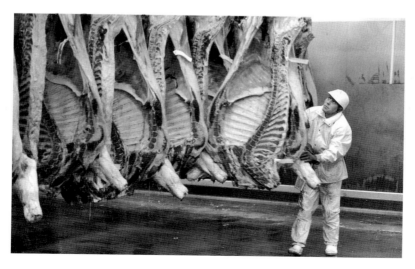

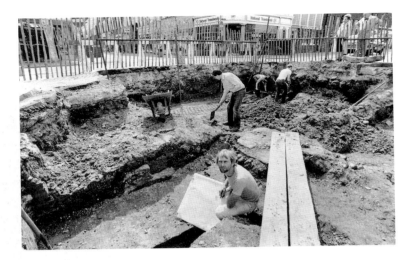

Archaeology

One of Hull's most notorious landmarks was re-emerging from under tons of concrete and clay in July 1986. An archaeological dig on the edge of the city's Old Town revealed part of a wall adjacent to the ancient Beverley Gate. It was there in 1642 that King Charles I was refused entry to the town by the Parliamentary populace led by Sir John Hotham. The excavation was being carried out prior to a pedestrianisation scheme.

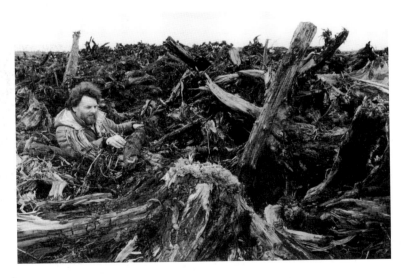

Archaeology

A Bronze Age forest, described as the most important archaeological find of the decade, was discovered at Thorne Moors, near Doncaster, in 1993. It was uncovered by heavy plant machinery used by Fisons to drain the moors and scrape layers of peat for sale as horticultural compost. Dr Paul Buckland, a lecturer in archaeology and prehistory at Sheffield University, said in the YP of 23 April 1993, 'This is a truly remarkable find ... It provides the most substantial evidence yet that Neolithic and Bronze-age man did not cut down or burn forests at random as had been previously thought but operated an organised system of managed forest and pasture land.' The picture shows Dr Paul Buckland examining the ancient trees.

Archaeology

Sandal Castle stands in a commanding position overlooking the River Calder. It was probably first built in the early twelfth century, after William de Warenne received the Manor of Wakefield from Henry I in around 1106. The earthwork motte-and-bailey castle was probably completed by 1130. The archaeological evidence suggests that the rebuilding in stone started at the very end of the twelfth century and continued throughout much of the thirteenth century. Sandal Castle is perhaps best known for the famous Battle of Wakefield, which was fought nearby in 1460 during the Wars of the Roses. Richard, Duke of York, was killed in the battle. During the English Civil War in the 1640s, Sandal Castle was besieged twice by Parliamentary forces. Afterwards, it was stripped of its defences. Displays about the history of and life in the castle can be seen at Sandal Castle Visitor Centre and Wakefield Museum. Both have a selection of finds from the excavations of 1964–73. Archaeologists are seen here at the dig in June 1972.

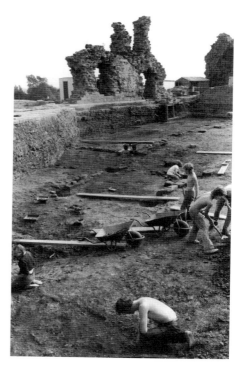

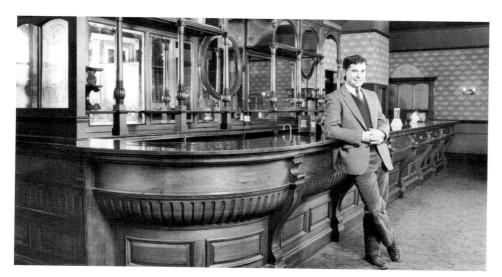

Architectural Antiques

Andy Thornton Ltd, presently based in Elland, West Yorkshire, was established in 1975 when Andy and Kate Thornton began exporting architectural antiques to restaurants and bars in America. Over the ensuing years, the business has expanded and diversified and is now a global company supplying products and services around the world. Andy Thornton is pictured leaning on a mahogany bar in the Peel Hotel, Boar Lane, Leeds, which he bought at auction in February 1984.

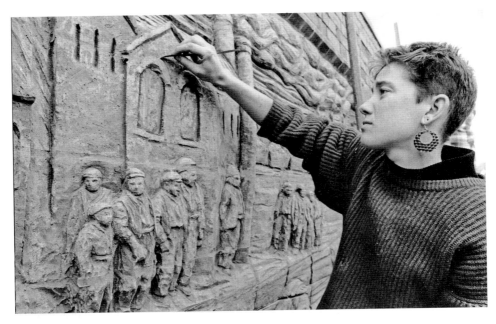

Arts

In February 1990 Julia Barton is shown putting the finishing touches to her brick mural in Featherstone. The sculpture was part of the Featherstone Garden Project, sponsored by Wakefield District Council. Built on a street in a derelict part of the town centre, the mural charts Featherstone's mining, industrial and geological heritage. All the materials for the project, which had begun the previous summer, were provided by local firms.

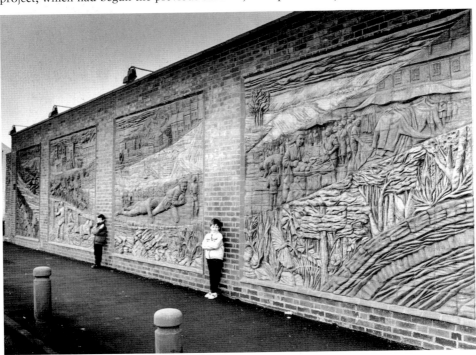

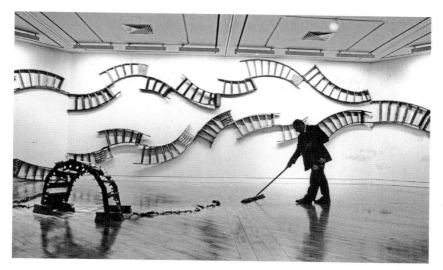

Arts

Attendant Brian Scargill joins in the mood of an exhibition at the Ferens Art Gallery, Hull, by local sculptor Andi Dakin, which consisted of a collection of disused stepladders and sweeping brushes. The exhibition took place in 1994.

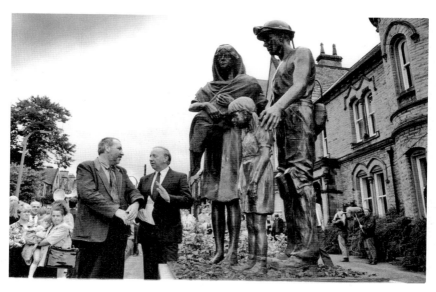

Arts

In July 1993, miners unveiled a tribute to the friends and colleagues who had lost their lives during three centuries of the coal industry. Barnsley sculptor Graham Ibbeson was commissioned to create a memorial sculpture to stand outside the headquarters of the National Union of Mineworkers in the town. His work, cast in bronze, shows a miner and his family standing, heads slightly bowed, in memory of the hundreds of workers who died in the pits or fighting for better conditions. Union president Arthur Scargill performed the unveiling ceremony at the Huddersfield Road headquarters. He said it was a fitting tribute to the miners who had paid the ultimate price for their industry.

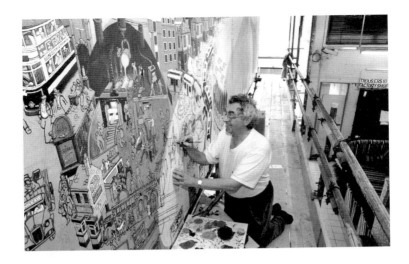

Arts

Sheffield artist Joe Scarborough is pictured in May 2000, halfway through the monumental task of painting a 70-foot by 7-foot millennium mural, which was stretched across a wall in the Castle Market in the city centre. The giant painting, when finished, was to have a permanent home in the new retail market being built as part of a leisure and market development in Castlegate. Joe, born in Pitsmoor, Sheffield, in 1938, was a former face worker at Thorpe Hesley Colliery before becoming a professional artist. His work is represented in many public and private collections at home and abroad.

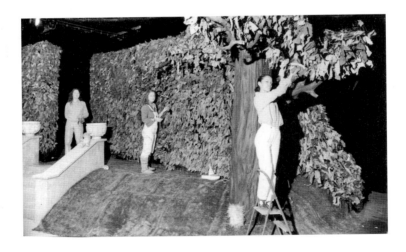

Arts

Over 20,000 leaves were included in a production at Leeds Playhouse during February 1980. Seen putting the finishing touches to the leaves on the set are (from left to right) Mishel Riley, Celia Johnson and Carol Morris. They were part of a team of girls that worked right up to the last minute before opening night to put the array of leaves into place on the production *Joking Apart*. Mishel was working at the Playhouse under a Youth Opportunities Scheme and, along with two girls from St John's College, York, had spent the previous three weeks cutting out the leaves from dyed and fireproofed canvas. Celia and Carol belonged to the Playhouse staff. The play was about married relationships.

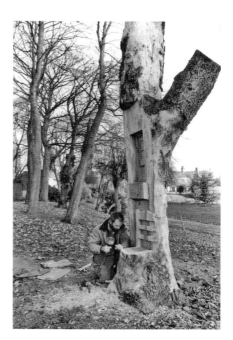

Arts

The *YP* reported, in November 1993, that the passing of the elm was being marked by sculptures in parks. Sculptor Colin Wilbourne had spent weeks working at Greenhead Park, Huddersfield, on one of the last remaining elms in the area. Kirklees Council had removed more than 140 trees, victims of Dutch elm disease, and the sculptures were to commemorate the species.

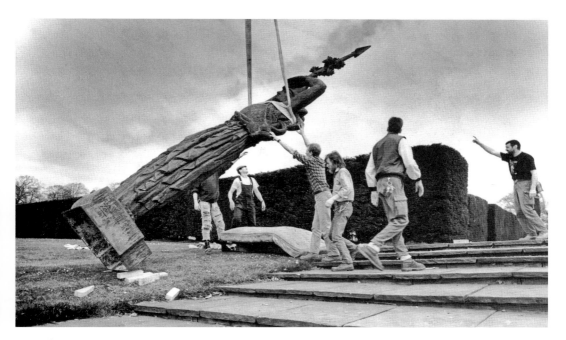

Arts

In May 1989, Wakefield's 'Ideas into Action' programme included a project that envisaged developing the Sculpture Park at Bretton as an international attraction. The park took another step forward when a new exhibition opened – the largest open-air example of French artist Bourdelle's work ever mounted. Park staff are pictured hoisting the artist's massive 26-foot-high bronze, *La France*, into place, one of several monumental works in the exhibition.

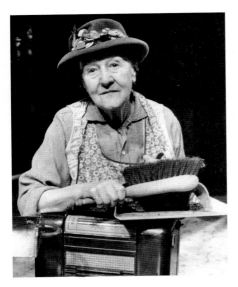

Arts

In July 1975 the *YP* thought that Madoline Thomas was the oldest regular working actress in the country. She is pictured as she appeared in *The Shop at Sly Corner* at York Theatre Royal. As Mrs Cat, the charwoman in Edward Percy's thriller, she wore the hat donned by the late Ada Reeves, who played the part in the original production. 'She gave it to me when she retired,' said Miss Thomas, who trod the boards for sixty-nine years.

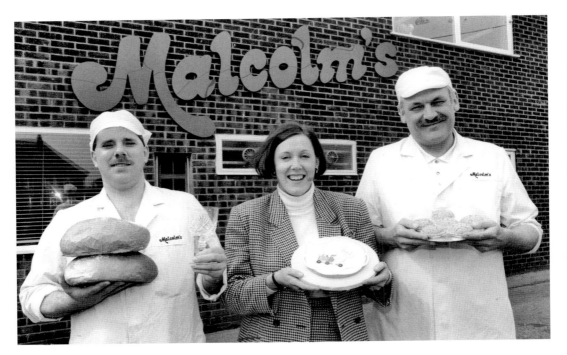

Bakers

Having entered their twenty-sixth year at the beginning of 1993, Malcolm's, the family-owned bakers and confectioners, were continuing their impressive record of growth. From the foundations laid by Malcolm Lanfranchi in 1967, the firm had expanded into both retail and wholesale markets. The retail division was headed by Sharon Lanfranchi, retail sales manager. Within shops based in Leeds, Horsforth, Pudsey, Seacroft, Castleford and Pontefract, various types of award-winning bread and mouth-watering confectionery items were to be found. These ranged from cream cakes to caramel slices, French sticks to fruit pies.

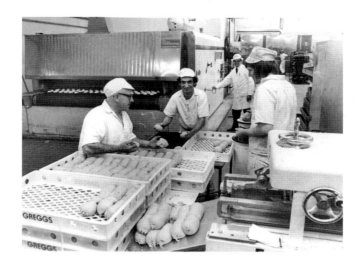

Bakers

Inside Thurstons' new £250,000 head bakery at Bramley, Leeds, in October 1974. The *YP* stated that the company showed the best in technology, hygiene and congenial working conditions. The new bakery was opened by the Lord Mayor of Leeds, Cllr Mrs Joan De Carteret. Thurstons began in a modest way in the 1950s, trading from a small shop-cum-bakery in Kirkstall Road, Leeds. By 1974, the company employed a staff of several hundred and had twenty retail shops.

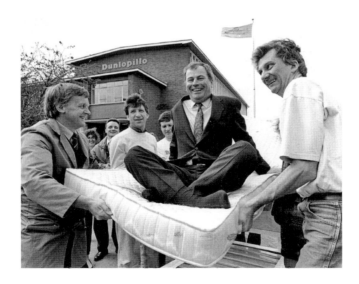

Bedding

In 1991, Dunlopillo, then the UK's only manufacturers of latex beds, had recently won the Queen's Award for Export Achievement – the first time the company and its 520 employees had been nominated for the accolade. Peter Shoubridge, Dunlopillo's export director, believed export success was a matter of changing people's outlook and developing an imaginative sales approach. Using these techniques, his own product knowledge, contacts and knowledge acquired from twenty years' trading experience abroad, Dunlopillo's exports took off. He is pictured with staff at the company's factory at Pannal, Harrogate.

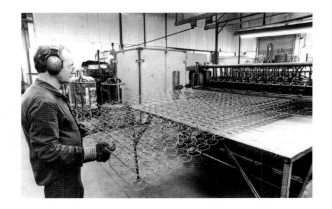

Bedding

A Layezee Beds worker is seen with a mattress spring-making machine. Before a mattress was made, spring wire was tested for various qualities, including tensile strength and extension characteristics. The *YP* of 24 June 1993 added that each time an operator at the factory completed a stage in manufacturing the product was stamped with a ticket, which could be traced back to an individual even years later. Also, each time an employee wanted to transfer to a different part of the production, or a new recruit joined, he or she had to go through detailed training.

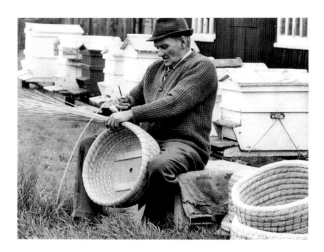

Bees

'One of the few remaining Yorkshire men able to make Bee skips – beehives woven from straw and cane – Mr John Skaife is keeping up the family tradition that is 200 years old,' stated the *YP* of 19 May 1970. The bees in the row of hives outside his workshop in Pickering were descendants of the English black bees kept by his great-grandfather. 'Nowadays, people buy the skips for decoration as often as for bee-keeping,' he said. 'But in my father's time he got up to two tons of honey a season from 150 of them kept on the moors. To make them you need wheat or rye straw cut in stooks, not baled. Luckily a farmer near here still uses a binder instead of a combine harvester.' John, a retired lorry driver, took a day to make each skip and sold them to fellow beekeepers. 'I know of nobody else in the region who still knows how to weave the skip. But I have been asked to teach the art to school pupils and I will be glad to do it,' said John.

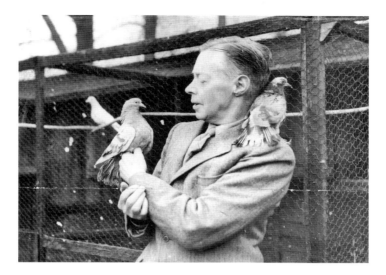

Bird Expert

Captain Reginald William Vietch was a well-known bird expert of Garforth, Leeds. In his obituary in the *YEP* of 24 August 1955, it was stated that he made a life-study of birds and was a well-known judge at bird shows, as well as a writer and lecturer on the subject. During the Second World War he served in the Home Guard, attained the rank of captain, and was awarded the MBE for bomb-disposal work. At his home in Garforth, he kept 200 pet birds, a collection he began twenty-two years previously with a budgerigar. 'Captain Veitch was the friend of all bird lovers and was always ready to help with sick or injured pets,' explained the newspaper.

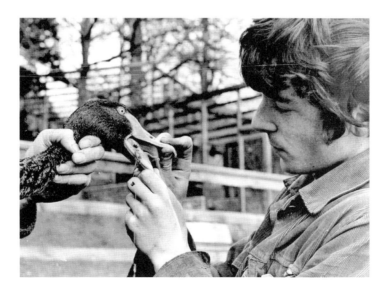

Bird Dentist – Open Wide, Cobber

In April 1972, an Australian black swan received a little delicate dentistry from Brian Hood, one of the assistants at Harewood House bird garden near Leeds, after getting tangled almost 'hook, line and sinker' by a fishing line. When staff caught him, they found the line wrapped round his tongue and the angler's float dangling from his beak.

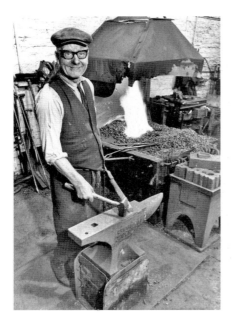

Blacksmith

'As far as I know I am the only self-employed blacksmith left in Leeds,' Albert Marshall, sixty-two, told the *YP* in March 1973. He worked as a general blacksmith in Goodman Street, Hunslet, and added that he no longer shoed horses and that 50 per cent of his work was in making the iron framework to support gymnasium equipment. 'I also do fire-welding, which I should think that very few people still know how. I weld metals together in the fire while others use gas or electricity.'

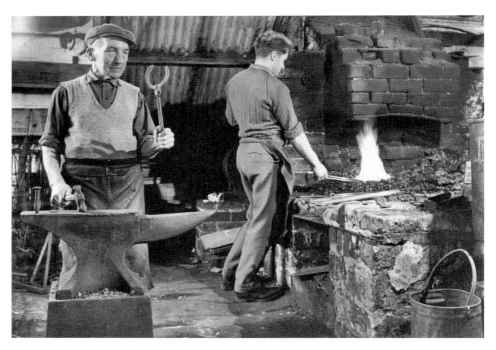

Blacksmith

On 7 February 1962, the *YP* stated that blacksmiths throughout the country had great difficulty in finding young men to carry on the traditions of their craft. But Mr Stanley Thompson, twenty, seen here working at a forge, had completed a six-year apprenticeship under Fred Garten, sixty-eight, at York Road Forge, Wetherby, and hoped to carry on as a farrier for many years.

Bottling

The picture shows bottles at the end of the Lax & Shaw production line during October 1984. About 80 per cent of the company's output at that time was sold to the liquor trade – Bell's, Queen Anne and Long John whisky and Vladivar vodka were among the best-known brands to be supplied by the firm. The picture was used to illustrate an article detailing the Leeds-based company's installation of a £2.75 million modernisation programme. This included the introduction of a new production line, which was capable of turning out more than 250,000 bottles per day. In 1984, Lax & Shaw employed some 275 people.

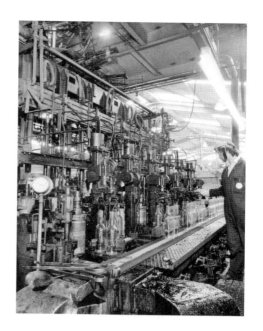

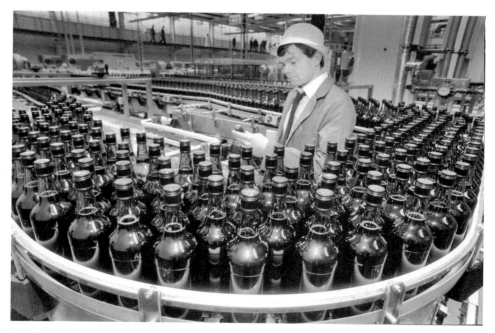

Bottling

Foreman Tony Murphy keeps a check on one of two new bottling lines at Matthew Clark's Barchester Winery, Leeds, in August 1993. The new lines, officially opened by the chairperson of the Customs and Excise, Mrs Valerie Strachan, were installed to speed up production at the winery, which produced Old England British Sherry and Stone's Original Ginger Wine. 'We can now produce more than five million cases a year,' said Michael Cottrell, the chairman of Matthew Clark.

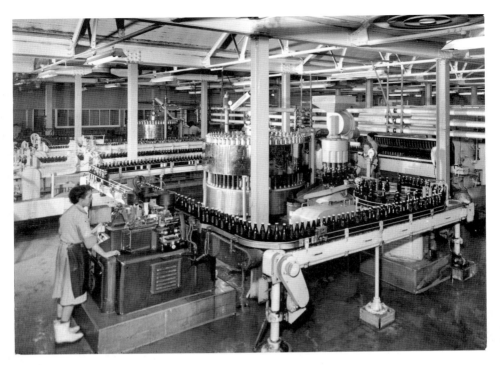

Bottling
One of the automated lines in Tetley's store at the Brewery, Hunslet Road, Leeds, in June 1965. The machine in the foreground labelled the bottles as they passed by. On each of these lines, bottles were washed, filled with beer, crowned and labelled at the rate of up to 360 a minute. Machines emptied and filled crates mechanically.

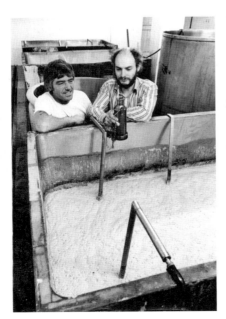

Brewers
Brian Eastell and Peter Wesley are pictured in a brewery housed in part of the old Turkey Mill at Goose Eye, a small hamlet near Keighley, in September 1979. Brian, a former builder and landscape gardener, had bought the mill and employed Peter, formerly of Theakston's, to brew beer for his pub, the Turkey Inn, situated in the village. As the village was without proper sanitation, Brian was also a prime mover in solving that problem. The *YP* of 6 September 1979 described Goose Eye as a relic of the Industrial Revolution – a crumbling memorial to one John Town, who built a writing-paper factory (Turkey Mill) there in 1822.

Brewers

During October 1995, Courage Tadcaster celebrated the news that its commitment to quality had been officially recognised. Staff at the John Smith's brewery in Tadcaster heard that they had been successful in their first attempt to gain the international British Standards quality assurance certificate. The award came after an intensive and rigorous review of Tadcaster's operational processes by BSI auditors. 'Our success is a real tribute to staff, who are genuinely committed to quality and giving our customers the best service that they can,' said director John O'Brien.

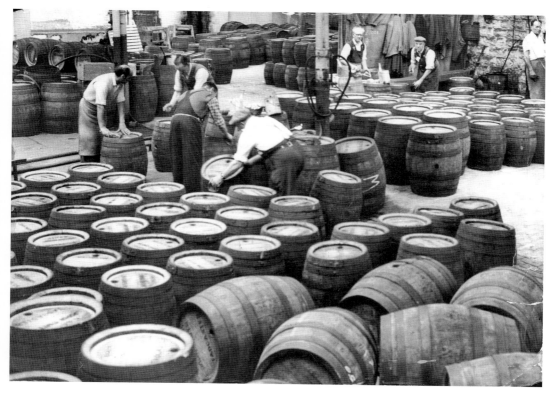

Brewers

'Tadcaster means beer. In 1847 John Smith and six helpers began to develop the industry for which Tadcaster had been famous since medieval days. Less than 40 years later the staff was 100 ... Now behind the towering facade on the busy Leeds–York road 850 people help to brew the firm's ales,' stated the *YEP* on 12 July 1963. The picture shows men working in the brewery's 'clean barrel' room. This was where the empty barrels – after being returned from pubs – were cleaned for use again.

Brewers

Geoff Hill of Halton, Leeds, peers into one of the giant stainless steel mash-conversion units at Tetley's Leeds brewery in September 1993. As part of National Brewery Month the *YEP* and Joshua Tetley were giving readers the chance to visit the brewery, and at the same time raise money for the Macmillan Nurse Appeal. For £5 donated to the appeal, visitors were given a tour of the brewery, lunch and drinks.

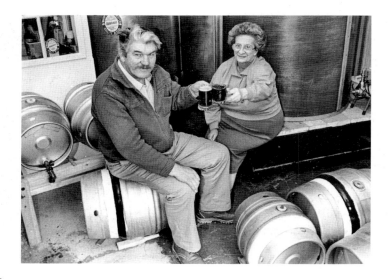

Brewers

Brewers Duncan Evans and his wife Joan drink a toast with one of two new beers that they had produced in Whitby – Woblle bitter and Ammonite bitter – in June 1988. The Woblle strong ale was so called partly because of its effect and also as a deliberate misspelling of the initials of their company, Whitby's Own Brewery Ltd. Duncan, fifty-seven, was a former industrial chemist and fisherman and began his one-man brewing business with a grant from the Department of Trade and Industry.

Bridges

Workers are involved in manoeuvring a
£130,000 bridge into position at Aldwark
Manor golf course near York. The bridge,
designed by Ove Arup & Partners of Leeds,
linked the old and new halves of the golf course.
A 500-ton mobile crane helped lower the 30-ton,
60-metre-span, steel-framed bridge with timber
deck into place.

Bricklayer

Miss Zoe Hodgson, seventeen, of Eccleshill, was Bradford College's first female student
bricklayer, reported the *YEP* of August 1995. Zoe worked for Thompson & Co. of Ward
Street, Bradford, and had impressed college lecturer and member of the Guild of Bricklayers,
John Offless, who said, 'It is the first time we have ever had a female bricklayer on the
course and at first there were some comments, but she has done very well.' He added
that she was obviously a quick learner because her exam results had placed her above the
halfway mark in the group's ability range. Zoe joined the course late after trying another
construction course that did not provide the bricklaying that she wanted to do.

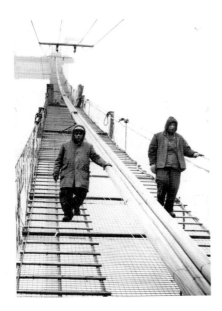

Bridges

During February 1978 a number of men had to stop working on the Humber Bridge because of the freezing weather. Two steel erectors, John Mellors (left) of Hull and Tony Swallow of Doncaster, are pictured making their way down the catwalk to the bridge anchorage point. It was the first time they had worked on a suspension bridge. They were working on the spinning of the main cables across the Humber.

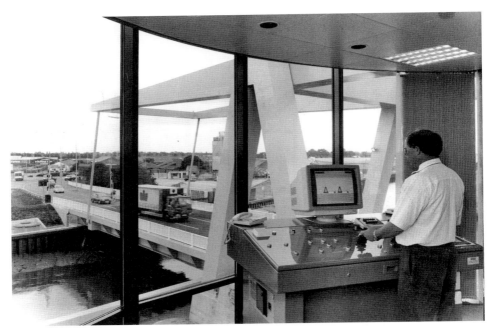

Bridges

Stoneferry Bridge, crossing the River Hull between Clough Road and Ferry Lane, was built in 1905. By the 1980s it was too narrow for two lorries to pass and became a notorious bottleneck. 'The new bridge [completed in 1991] is a remarkable engineering feat,' said the *YP* on 4 November 1991, adding that it was controlled by the most advanced computer technology possible, as can be seen here. But it was pointed out that a series of backup and monitoring systems were at hand to alert operators to potential faults. And, if all else failed, the bridges could be operated manually.

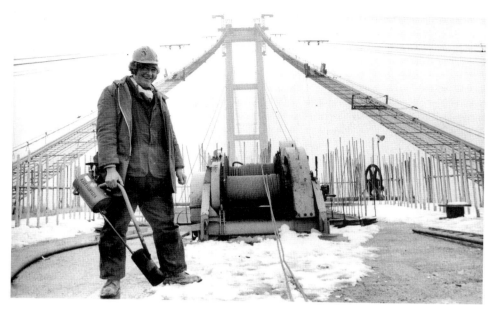

Bridges
To help him work in freezing conditions on the Humber Bridge, Charlie Amos carries a flamethrower, which was used to melt ice in February 1978.

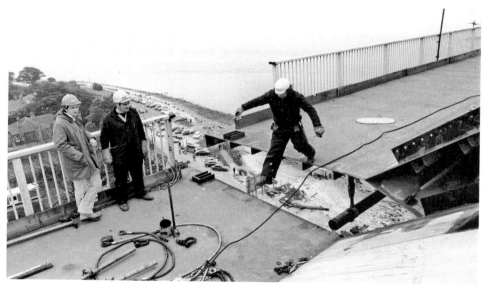

Bridges
The final section of the Humber Bridge swung into place on 17 July 1980. In the picture, a worker jumps the gap as the last section locks in above the Humber. The *YP* of that date reported that it took 42 tense minutes for the box section to be winched into position on the side span at Hessle. The operation went smoothly apart from a few minor hitches with the winch cables.

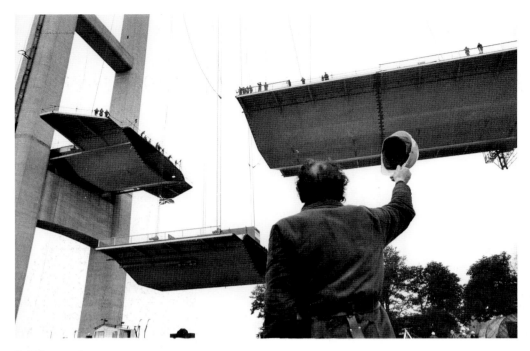

Bridges

On www.humberbridge.co.uk it is stated that work began on the bridge in 1973 and continued for eight years, during which time many thousands of tons of steel and concrete were used and upwards of 1,000 workers and staff were employed at times of peak activity. On 17 July 1981, HM the Queen performed the formal opening ceremony. From 1981 to 1998 the Humber Bridge was the longest suspension bridge in the world.

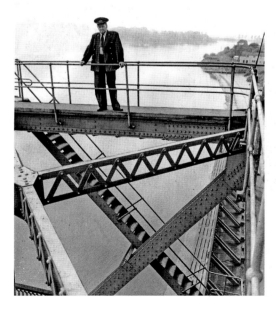

Bridges

'Three men on the staff of the [Boothferry] bridge, a dominating structure of latticed girders, have been there since the bridge opened [on 10 July 1929],' informed the *YEP* of 13 June 1959. They were the bridge master, Palmer Gore, and two brothers of a family who were the only ones to protest when the plan to build the bridge was announced. Harold Robinson, sixty-three, and John Henry Robinson, fifty-nine, pictured, along with their late father were the last ferrymen of Booth. They took over the ferry in 1918 and based their protest against the bridge on the grounds that it would take away their livelihood. Their protest was swept aside and the two brothers started work on the bridge on the day it opened.

Two

Bus Conductor to Coastguard

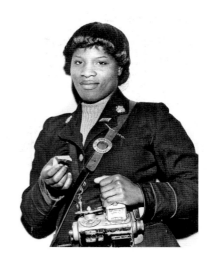

Bus Conductor

On 25 March 1960 the *YP* reported, 'In a downstairs room in the centre of Bradford, the Corporation Passenger Transport Department's first coloured woman bus conductress is learning the theory side of the art of collecting fares.' This was Christine Humphreys, who had arrived in the UK from Dominica four years earlier. Christine was working in a local hospital when she saw an advertisement in the Corporation buses appealing for female conductresses. She applied and was accepted.

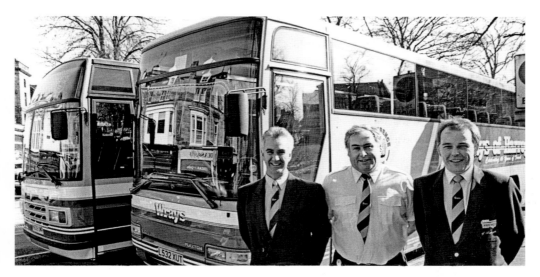

Buses

During April 1994 the *YEP* offered congratulations to Wrays of Harrogate, the family that specialised in coach travel. It was sixty-five years since Wrays first carried passengers. It was also significant that in its sixty-fifth-anniversary year the family firm had taken delivery of a forty-nine-seater luxury coach valued at £150,000. The coach, built in the UK with a Volvo chassis by Plaxtons, was considered to be the Rolls-Royce of the coaching industry. The new coach is welcomed by Malcolm Wray (left) and drivers Ray Harrold (centre) and Colin Thackray.

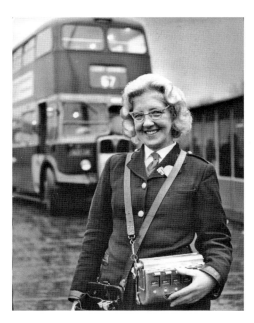

Bus Conductor

The *YEP* of 20 January 1967 stated that Mrs Agnes Brown cut a trim figure in her green uniform: '[She] works on a stop-go principle. In fact her life is full of stops – bus stops.' Agnes, chirpy, blonde and a granny, was a conductress with Leeds City Transport. She had been in the job for nineteen years and told a *YEP* reporter that she thoroughly enjoyed her job. 'You meet a lot of different people,' she said.

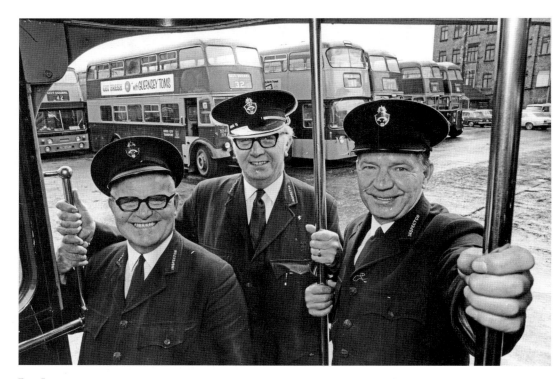

Bus Inspectors

Three Leeds City Transport bus inspectors who had joined on the same day were to retire on the same day in July 1972, announced the *YP*. They were, from left to right, J. W. Woodhead, L. Cluderay, and L. Cheetham.

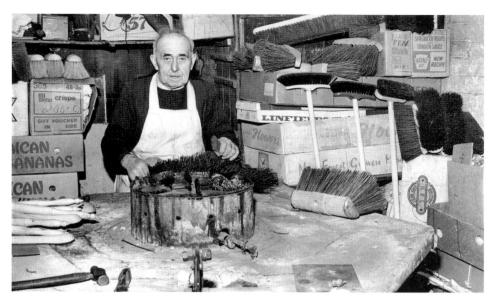

Brushmaker

'John England, 82 has been in the brushmaking trade tucked away in a quiet corner of Pontefract, since 1904,' reported the *YP* of 15 November 1972. He had decided to retire as a garage wanted his premises for extension but the equipment in his workshop was to be preserved in a museum. Most of the equipment dated from the turn of the century. A team from the Pontefract Archaeology Society had been recording the anecdotes of John, who was thought to be Britain's oldest brushmaker. Eric Holder, a schoolmaster and member of the society, said, 'We have photographed Mr England at work and recorded his reminiscences. Arrangements are being made to transfer the interior of the workshop to a new folk museum in the Wakefield area. We are building up a picture of a vanishing world.'

Buskers

Under the gaze of an unamused Queen Victoria, buskers defied the elements while practising for a competition that was to bring music to the ears of Hull shoppers. On a wet and windy day in June 1991, two duos – Matthew Hogg and Lynn Acton, and Fenix and Lorenzo – tuned up in Queen Victoria Square, rehearsing the pieces they hoped would lead to success in Hull's fifth busking competition during the following week. The competition was expected to attract around twenty buskers and was part of the week-long 'Summer in the City' project. Summer in the City was sponsored by the Hull Safer Cities project and was aimed at attracting families back into the city centre for entertainment and leisure.

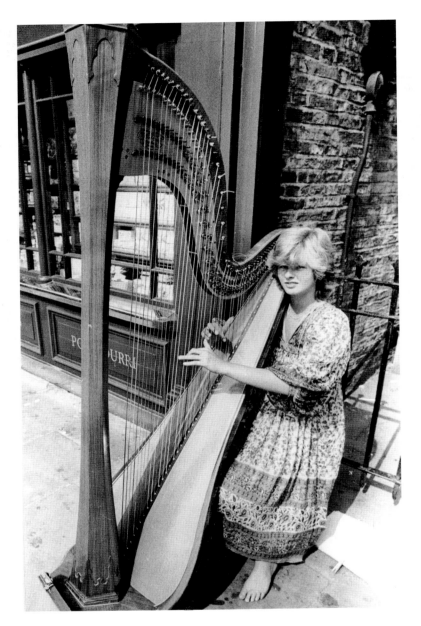

Busker

String-pulling Miss Fiona Clifton-Walker was busking in York during August 1984 on a £6,000 harp, and attracted huge crowds. Fiona, nineteen, from Portsmouth, was studying for a BA honours degree in music at York University and using an old golf trolley to ferry her harp around the streets after taking a taxi ride with it from the campus. She performed barefoot. Her recitals of Handel and Debussy were so good that shopkeepers in Stonegate had to ask her to move on one day because crowds blocked the entrances to their premises. Fiona also took part in university concerts, but she said, 'I can sit and perform for people on the streets without having to be nerve-wracked like a concert performance. It is enjoyable and my parents think it is enterprising.'

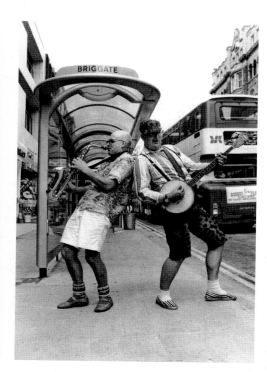 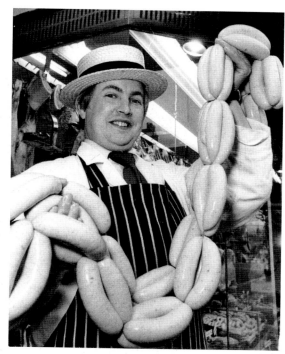

Above left: **Buskers**

Buskers Moon de Lune take their two-man act on a bus-stop tour of Leeds in July 1993. It was part of a 50-mile trip to nine different town centres as a prelude to the Leeds Centenary Wind Festival.

Above right: **Butcher**

A Yorkshire firm of family butchers established a link with royalty in November 1978 by delivering a very special batch of sausages to Buckingham Palace. Clayton's, of Brook Street, Ilkley – noted champion sausage-makers – received a royal invitation from the Queen's private secretary requesting them to send a batch of their prize pork sausages to the palace for Her Majesty to sample. They were delivered to Buckingham Palace kitchens personally by the proprietor of the business, Francis Copley, and his wife Valerie. Francis is pictured with the Royal Links.

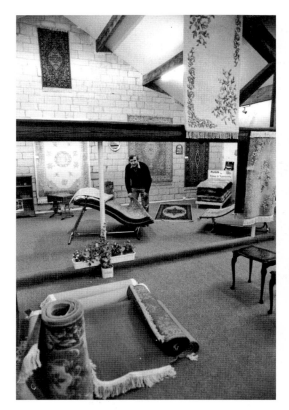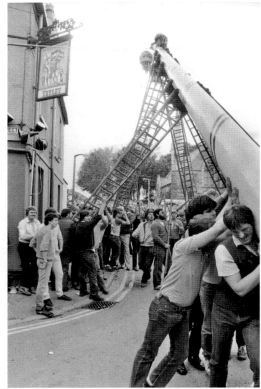

Above left: **Carpets**

'Success and class are two attributes which are not only compatible but often go hand in hand when it comes to business – and Geoff Chappell certainly knows how to blend them,' stated the *YP* of 1 October 1983. After thirty-five years in the carpet business in Bradford, twenty-five of which he spent running his own successful shop, Geoff decided to sell up and start afresh. He found a two-storey building in Glusborn near Keighley, which was formerly a barn and hayloft, and converted it into the new showrooms of the Carpet Gallery. 'His success and class is shown as soon as you walk in the door,' observed the *YP*.

Above right: **Ceremonies**

In May 1984 a strong-arm operation by dozens of villages brought a successful end to Barwick-in-Elmet's triennial Maypole Raising festival. In front of a crowd of more than 4,000, villagers coaxed the 88-foot maypole into position using ladders and ropes. Then the newly painted pole – being raised for the first time since it was vandalised in 1981 by a climber wearing spikes – was the centre of a display by morris dancers. A twentieth-century touch was given to the 900-year-old ceremony when a hoist belonging to West Yorkshire Fire Service arrived to place the fox weathervane on top of the pole. Traditionally, a local man shins up to the top, but the Maypole Committee was unable to find insurance for the job, and members were unwilling to allow the climb to go ahead without it.

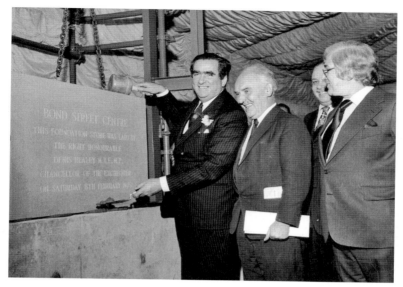

Ceremonies

Labour MP and Chancellor of the Exchequer Denis Healey lays the foundation stone of the £26 million Bond Street Centre, Leeds, on Saturday 8 February 1975. On the right is Sir Albert King, Leader of Leeds City Council. After laying the foundation stone, Denis Healey said that the new development would become a place of pilgrimage for planners from all over Europe.

Ceremonies

The *YP* of 1 May 1970 revealed that every year a short service was held round St John's Well in the village of Harpham near Driffield, East Riding, to commemorate the birth there of St John of Beverley, the founder of Beverley Minster. Mrs G. A. Hall is 'dressing' the well in readiness for a service.

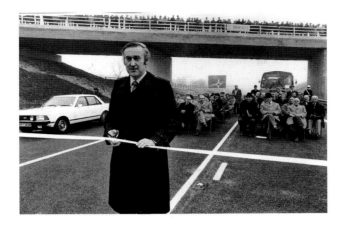

Ceremonies

Skipton's multimillion-pound northern bypass was officially opened in December 1981. The tape was cut on the bypass itself by the town's MP, John Watson, as around sixty seated guests looked on. Mr Watson is seen cutting the tape. A line of spectators are watching from White Hills Bridge. Mr Watson said the new road was a good example of government transport policy, which gave priority to bypasses that would take traffic out of historic towns. Together with the western section, which was to open the following year, the new road would give Skipton a new lease of life, and allow the townsfolk and visitors to rediscover its charms.

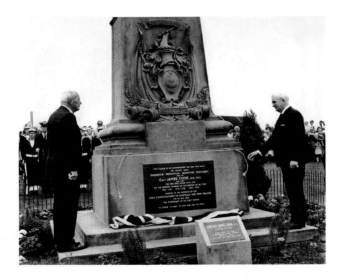

Ceremonies

A scene at the Captain Cook monument in People's Park, West Cliff, Whitby on 26 August 1968, where a plaque was unveiled to mark the bicentenary of his first voyage of discovery. Sir Denis Blundell, High Commissioner for New Zealand, and John Knott, Acting High Commissioner for Australia, jointly performed the unveiling duties. The plaque commemorated the men who built the Whitby ships *Endeavour*, *Resolution*, *Adventure* and *Discovery* used by Captain Cook and the men who sailed with him on his great voyages of exploration. At a civic luncheon attended by over 140 guests, Sir Denis referred to the debt that the people of his country owed to Captain Cook.

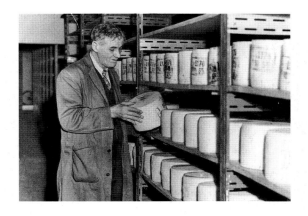

Cheesemaker

The *YEP* of 8 November 1955 stated that Wensleydale cheese was setting itself up as a rival to the famous blue cheeses – Danish Blue, Gorgonzola and Blue Stilton. Part of a hillside had been dug out at the Wensleydale creamery at Hawes, and a new storehouse had been built to hold 10,000 Wensleydale cheeses. Mr Kit Calvert, managing director of the creamery, said, 'Blue Wensleydale has been made on farms in the past, but only by chance. Nobody could say how it was done; the cheese either "blued" or it didn't "blue". We are hoping to find out just how the blue mould is caused.' 'During the previous 40 years,' said Mr Calvert, 'ploughing, spraying and artificial fertilizers had destroyed much of the character of the herbeage eaten by cows that produced milk for Wensleydale cheeses.' The picture shows Mr Calvert at his factory.

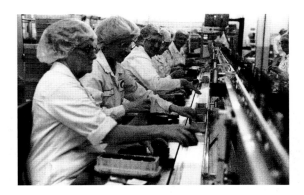

Chocolate Makers

'From Yorkshire to the Himalayas and the Andes, to deserts and the frozen north, that's the After Eight Mint,' stated the *YEP* on 6 January 1993. In the previous year the Nestlé Rowntree sweet factory in Wheldon Road, Castleford, had turned out millions of the wafer-thin mints and packed them off to every corner of the world. Exports of After Eights, which had more than doubled in the previous two years to over 4,000 tons, tickled the palates in Nepal, Central and South America, the Middle and Far East, and the Falkland Islands; though by far the lion's share went to Europe, where the French and the Swedes were the biggest munchers. As well as its £29 million in After Eights, which took up almost half the home market, the Castleford plant also made Toffee Crisps. Factory manager Jonathan Box said, 'The hard work and high standard of the employees have produced a consistently good quality product which has helped make After Eight the success it is.' The picture shows Castleford production line staff packing After Eight mints.

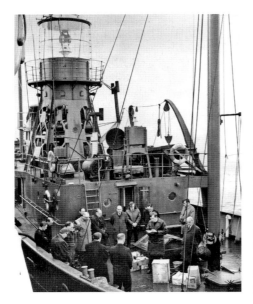

Christmas

Christmas fare is piled on the deck of the *Spurn* lightship in the Humber estuary shortly before Christmas 1969. The crew gather round the Missions to Seamen chaplain, the Revd William Down, for a service. The chaplain was making his Christmas visit to the lightshipmen who would spend the festival away from their families in order to safeguard shipping in the waterway.

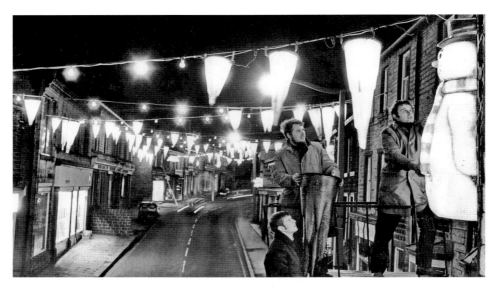

Christmas

Traders are seen putting the finishing touches to Christmas illuminations at Honley, near Huddersfield, in December 1971. During a 'switch on', local tradesmen said that ten months of fundraising had been well worthwhile. The illuminations, resembling snowmen, chess pieces, stars and other objects, were bought from surplus stocks of Blackpool Corporation. 'We wanted to do something to brighten up the district and started working for these illuminations soon after last Christmas,' said Mr Dyson, a member of the Holme Valley Chamber of Commerce. In addition to fundraising, chamber members had erected the lights at Honley and in the centre of Holmfirth. 'When we have finished the illuminations will have cost us over £1,000,' Mr Dyson added. Depicted in the picture are (left to right) Robert Combes, Peter Dyson and Alan Edmondson.

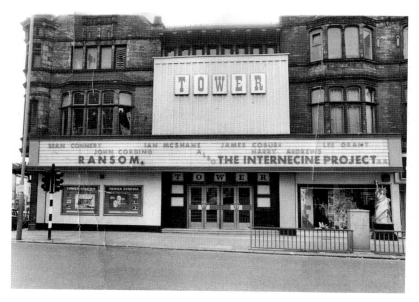

Cinema

Tim Mellor, eighty-three (below), who was the projectionist at the Tower Cinema, Leeds, when it opened in 1920, was to witness its closure in March 1985. He made a special request to the cinema's manager, Mrs Joyce Stocks (left) to be there at the end. He was to take along his wife, Grace, who worked for a time at the Tower as cashier. Tim, whose cinema career started as a page boy at the Picture House, Briggate, Leeds, when he was thirteen, remembered the Tower's early days when silent movies were packing them in. 'Of course the projection equipment has changed since then. We ran four shows a day, between 2 p.m. and 10.30 p.m. There was no double feature, but a main film, a comedy and a newsreel – Pathé animated gazette.'

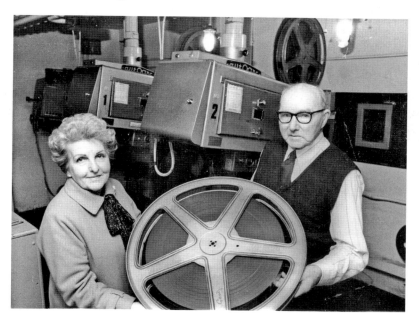

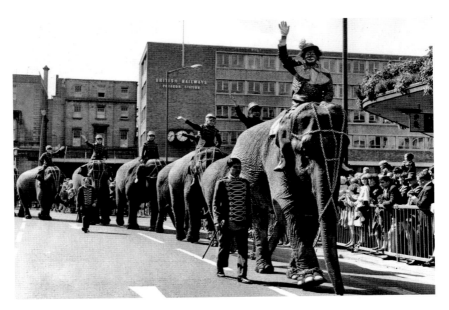

Circus

The *YP* of 1 October 1974 claimed there was a renewed interest in the circus – the high wire artists, ludicrous clowns and daredevil stunts – with forty travelling shows on the road in that year. Circus Fans' Association chairman John Stoker stated that perhaps one contributory factor was the agreed cut in the number of televised circuses. But Peter Featherston, manager of Sir Robert Fossett's Circus, pointed out there were problems recruiting labour: 'We need healthy young labourers who are single and prepared to travel. But why should they come and work for us when they could be working for anything up to £70 a week building motorways.'

Circus

'A show promising lovers of all things weird and wonderful has rolled into Leeds,' reported the *YEP* on 15 November 2000. The newspaper was referring to the Circus of Horrors which was beginning a five-day run at the city's Grand Theatre. The circus last visited Leeds in 1998 and critics accused it of tastelessness, but the organisers insisted their brainchild was nothing more than a piece of tongue-in-cheek fun. Depicted are Siam twins Byamba (left) and Suren, who performed with the Circus.

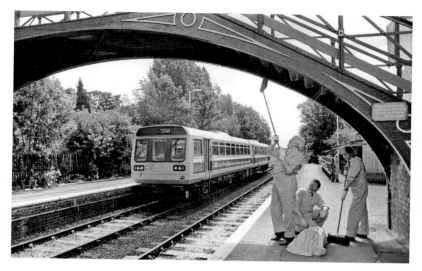

Cleaners

British Rail unveiled its latest weapon in the war against hooliganism in June 1990 when its mobile clean team swung into action. With an annual budget of around £25,000 the team was the first of its type on rural networks to be funded by BR. The three-man group had a simple brief – keep stations tidy. To do that they were equipped with a van loaded with equipment including brushes and mops to spruce up stations as well as paints and chemicals to remove graffiti. They were to travel in their van along the Hull to Scarborough line calling at the eleven stations en route. Pictured at the launch at Cottingham station are grime-busters Colin Hayward, Mick Wilstrop and Alan Schofield.

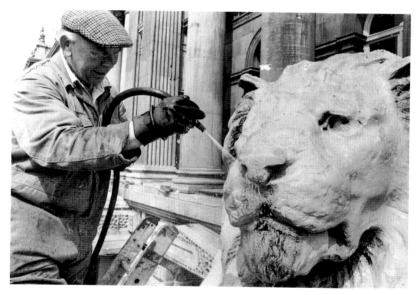

Cleaners

The *YEP* of 19 July 1972 reported that the sculpted lions in front of Leeds Town Hall were being given a continual soaking. This was to soften the stone for cleaning.

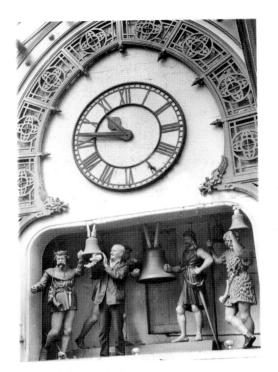

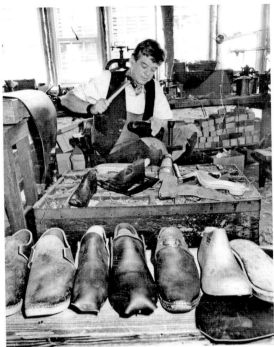

Above left: **Clock Carer**

Charlie Farrar, pictured, and his family have been around to look after the clock and figures in Thornton's Arcade, Leeds, since it opened in May 1878, reported the *YP* on 10 January 1977. 'My grandfather, Dan Marr, was appointed first caretaker in the arcade,' said Charlie. 'When Dan died, my adoptive father, also Dan Marr, took over the job and on his death in 1937, I took over and have been here ever since without a break.' The figures – Robin Hood, Richard Coeur de Lion, Friar Tuck and Gurth the Swineherd – stood about 5 feet 10 inches and were made entirely of wood. Charlie said, 'I have no set duty for cleaning the figures and only do it when they look dirty. It is quite a job clambering among them ... Until some 20 years ago the clock had to be wound three times a week by the clock's maintenance firm but since then has been electrically wound.'

Above right: **Clog Maker**

During October 1984 the Colne Valley Museum at Golcar, Huddersfield, held a craft and working weekend where visitors were able to see twenty different crafts being demonstrated in the museum's restored weaver's cottage. Pictured is clog maker Alan Cox, busy working in the clog maker's shop at the museum.

Clothes Maker

The *YP* in April 1994 announced that Montague Burton established by Sir Montague Maurice Burton (15 August 1885, Lithuania – 21 September 1952, Leeds) was to cease making suits. On 12 April 1994, the newspaper ran almost a whole page of readers' memories of working at the factory. Mrs M. Gledhill of Leeds submitted a photograph with the following information: 'This is my mother whose name was Mrs Annie Cooper. She was a tailoress at Montague Burton and the photo was taken of her for a special magazine that was going to Germany …'

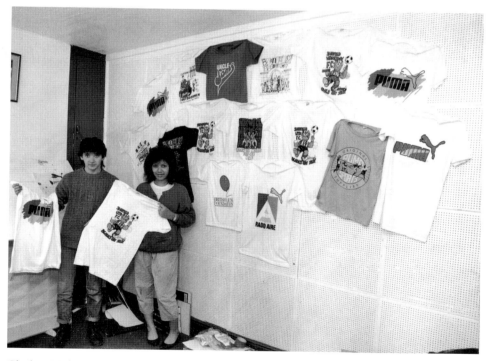

Clothes Makers

'One of the tried and tested methods of setting up a successful business is to spot changing trends in the market place and exploit it,' said the *YP* of 18 December 1987. Such an opening existed in printed tee-shirts, both as wearable souvenirs for fans and holidaymakers and walking advertising hoardings for sponsors and manufacturers. This opportunity was spotted by John and Paul Fowler and their friend David Wright, who left their regular day jobs to set up PFM Promotions, printing tee-shirts, in 1984. John Fowler said, 'The growth was far and away bigger and faster than we could have possibly foreseen at the start.'

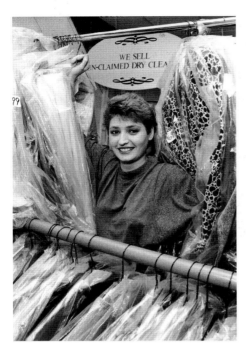

Clothing

During January 1993, customers crowding into a new clothes shop in Thornton's Arcade, Leeds, couldn't believe their eyes. Everything was priced at £6.99. But this was not a charity shop. It was an Aladdin's cave of forgotten dry cleaning. The Uncollected Dry Cleaning Company started with a shop in Newcastle, and Leeds was its second branch. The company's founder, Peter Harker, said, 'People get a real kick out of getting a bargain and to add to the fun everything is in plastic covers and there is a little label pinned on.' The picture shows Tracey Nicholson, twenty-two, sorting through a collection of garments.

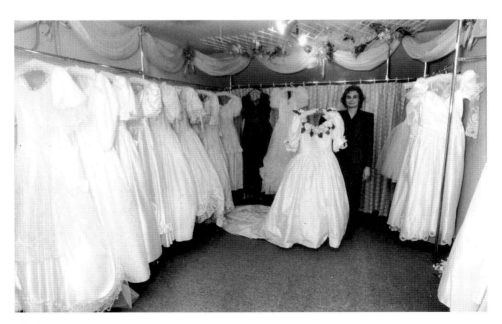

Clothing

In February 1990 a fashion shop in Barwick-in-Elmet was launching a new range of bridal wear. Joanna Blake teamed up with her mother, Rita King of Poppy, in Main Street, to introduce Bride at Poppy. The new bridal department was to be upstairs. Brides, bridesmaids and wedding guests would find, all under one roof, the complete wardrobe for the ceremony, reception and evening party.

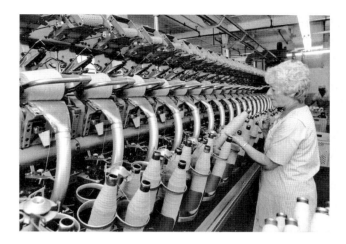

Clothing

Joseph Hoyle & Son's mill at Longwood Huddersfield housed a typical north-country textile business, established in 1865 and employing twenty to thirty workers at the outset. But by the 1920s it had become one of the most celebrated woollen spinning and manufacturing companies in England, providing employment for more than 2,000 Huddersfield men and women. Hoyle's became a member of the Lister Group from 1959. In this picture a Hoyle's worker operates a Savio automatic cone winder.

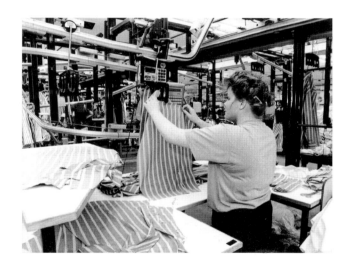

Clothing

On 7 June 1990, the *YP* noted that Isaak Donner was celebrating fifty years in business in the UK. Born in Poland, he fled in 1914 to Vienna, where he had patented his revolutionary collar-attached shirt with a replacement to be stitched in when the first showed signs of wear – each collar could also be reversed, hence the Double Two product name. Escaping from the Nazis he came to England and was encouraged by the Board of Trade to establish a shirt factory in the North, receiving help from the local bank and private investors. 'We took small premises in Kirkgate,' recalled Isaak, 'and started with a handful of girls.' By 1990, Double Two was employing 1,100. The picture shows 'sections being fed in for assembly into a shirt' at the Double Two factory.

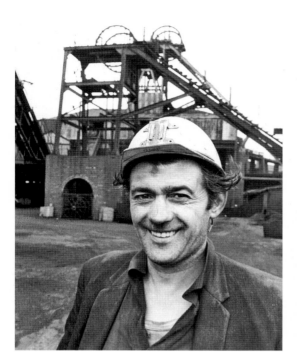
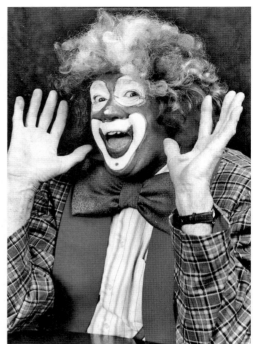

Above left and right: **Clown**

Ted Pickles, better known as Pickles the clown – his alter ego for more than thirty years – was buried at Netherton cemetery near Huddersfield after an emotional service in August 1998. He swapped pit grime for greasepaint full-time in 1985 when, as a miner at Denby Grange Colliery, he accepted a golden handshake from the Coal Board to follow his vocation as a freelance clown. After that, he never looked back. For ten years, during his days at the pit, he spent two weeks of his annual holiday learning his other trade with the James Brothers Circus in Mablethorpe, Lincolnshire. He went on to travel the world, bringing joy to thousands of people – mostly children – as well as raising money for charity.

Clown

Chuckles, Dipstick, Uncle Dippy, Ivo, Woo and at least a dozen more of their colourful friends were at Ted Pickles's funeral to pay their respects. The clowns wore their painted smiles but wept as they lined the entrance to the church in a guard of honour for the coffin.

Coal Miners

Members of the Disabled Miners Centre in Halfpenny Lane, Pontefract, at work on their mural dealing with the life of a miner, which was to be hung in the dining hall of the centre when completed. The disabled miners were working under the guidance of Maggie Fee of Mirfield, a community artist, who assisted the men to design the mural.

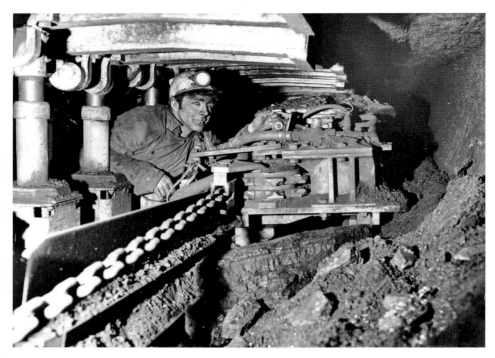

Coal Miners

Brian Matthews, twenty-nine, of Normanton, a member of the record-breaking team at Sharlston Colliery, Wakefield, keeps a close watch on the shearing machine that helped miners to produce over 23,000 tons of coal a week in 1971. Sharlston Colliery opened in 1865 and closed in 1993.

Coastguard

During February 1985, Flamborough coastguard Mike Coultas removes pieces of fishing nets from the nests of a gannet colony in a fight to save young fledglings from being trapped. The clean-up was supervised by the ornithologist Tony Soper and instigated by the Heritage Coast officer for East Yorkshire, Charles David, and the RSPCA and the RSPB. An increasing number of gannet fledglings had become trapped and died because adult birds were lining their nests with colourful and indestructible pieces of netting before they laid their eggs. Tony Soper said it would be preferable if the nests were not destroyed but because the modern nylon-type filaments were so intertwined with the nests over the years it was a difficult task.

Three

Construction to Floods

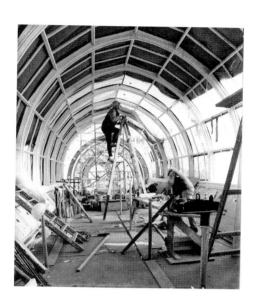

Construction

In October 1990 joiners Sam Roomes (left) and Jim Pembleton replaced rotten wood in the roof of Thornton's Arcade, Leeds. The arcade, which adds much to the character of shopping in Leeds, lies between Briggate and Lands Lane. It was built by the proprietor of the City Varieties Theatre in 1877 in a flamboyant gothic style. The glazed timber roof had severely deteriorated but was being extensively repaired and reglazed by John Laing Construction under the direction of Royall Worthington.

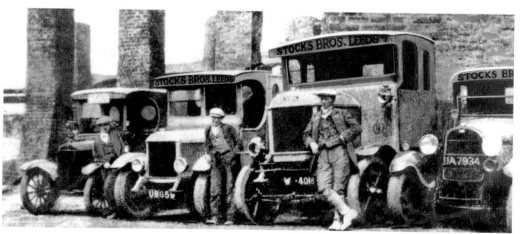

Construction

When the Stocks Group (a market leader in the block-making business) celebrated its diamond jubilee in 1988 it was announced that the company had built up its own transport fleet. This was to ensure control over the sometimes tricky logistics of guaranteed deliveries. An important aspect of the group's success was attributed to the loyal support of the transport team, some of whom had been working on the company's behalf for up to twenty years, sometimes running five vehicles each. The picture shows Stocks' transport fleet of the early 1930s.

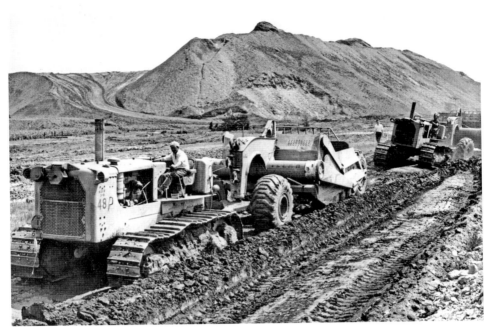

Construction
Workers in tracked scrapers remove topsoil from an area adjoining the Aire & Calder Canal at Swillington near Leeds in May 1970. It was part of a £40,000 scheme to reclaim land between the banks of the River Aire and the canal, stretching from the Garforth–Wakefield road to Water Haigh Colliery.

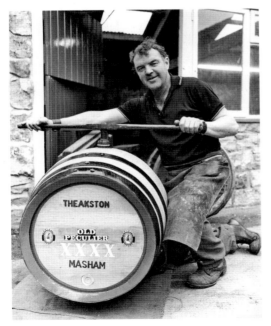

Cooper
Clive Hollis, a Theakston's cooper, is seen at work in November 1988.

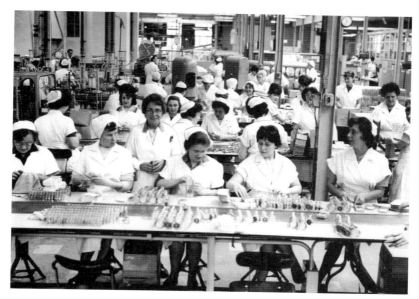

Cosmetics

On 11 October 1963, the *YEP* stated that these white-coated girls helped to turn out bottles of perfume and *eau de cologne* in one of the sweetest-smelling sections of the Gibbs Pepsodent Ltd factory at Whitehall Road, Leeds. At that time the factory was the largest toilet preparations manufacturing unit in the UK and the largest toothpaste manufacturing unit in Europe – with a worldwide market. Watching the girls is Mrs Dorothy Wigglesworth, a perfumery department supervisor with thirty-one years' service. 'I can't smell the perfume anymore,' she said.

Council Work

Cawthorne Parish Council called upon George Roberts, in August 1971, to help them in a bid to hold on to the title of 'Best Kept Village in South Yorkshire'.

Crane Driver

New Zealand-born crane driver Levi Ditchburn's workplace was the highest in Leeds during 2004/05, as well as one of the most complex. 'It's a world that involves nerve and physical fitness, precision, good hand-eye co-ordination, fine judgement, a micro climate, periods of contemplation and could result in motion sickness,' said the *YP* of 27 April 2004. His German-built crane was the largest being used by Gleeson's, the company building the £32 million City Island development of 404 apartments and penthouse suites, across the River Aire from the *Yorkshire Post* headquarters. During their eighteen months on the site, Levi and the crane's swinging jib – almost 150 feet long – distributed tens of thousands of tons of material around the site.

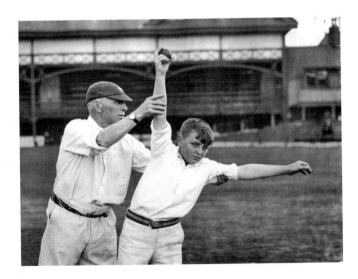

Cricket Coaching

Former Yorkshire cricket hero George Hirst gives a schoolboy some useful hints during an afternoon coaching at Park Avenue, Bradford, in August 1932. In his obituary in the *YEP* of 11 May 1954 it was stated, 'On the day he was 70, he said that he owed a lot to the young cricketers of Yorkshire – but he had been a fortunate man to have the chance of being Yorkshire's coach "for the youngsters have kept me young".' The *YEP* also recalled that Hirst 'in 1906 accomplished the feat of 200 wickets and 2,000 runs in a season'.

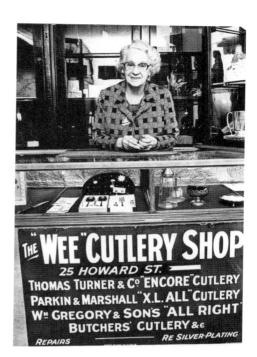

Cutlery
Mrs Ashby is pictured in the Wee Cutlery
Shop on Howard Street, Sheffield, in 1975.

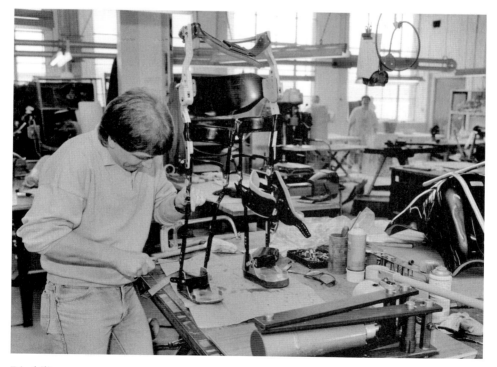

Disability
A worker at H. W. Poole's assembles a parawalker.

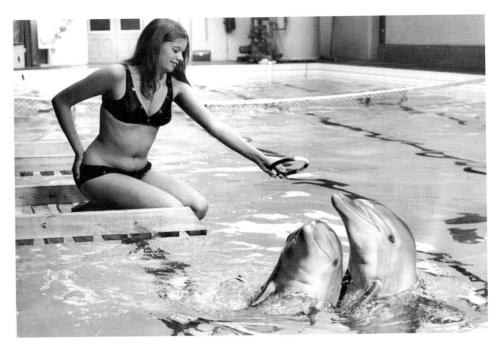

Dolphin Training

In March 1972, Miss Susan Shields, aged twenty, is pictured trying her hand at training dolphins, which had taken up residence in the old swimming pool at South Elmsall, near Pontefract. The dolphins, imported from North America, were being trained at the pool before being transferred to 'dolphinariums'.

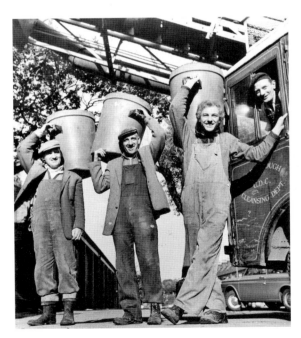

Dustbin Men

Dustbin men at Yeadon on 1 October 1969. They are, from left to right, John Appleton, Walter Kendall, Harvey Dwight and driver Albert Lawson.

Dustbin Men

In September 1970, Jim Whitehead, sixty-two, a dustman for Leeds Corporation for eleven years, revealed that his basic wage was £17 2s. He paid £4 6s 6d rent for his Corporation house in Rosedale Walk, Belle Isle, and other regular bills cost around £2 5s a week. He also had to provide boots and clothing for winter for what he described as a thankless job. 'People have the idea we earn £20 a week. It is ridiculous,' he said.

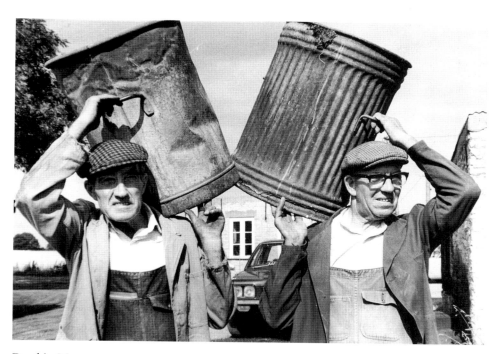

Dustbin Men

In August 1975 a public testimonial fund was being organised in Masham and district as a 'thank you' to the two men who had emptied 3,000 dustbins a week for twenty-seven years. Sam McCallum, fifty-eight, of Fitzalan Road, Bedale, and John Long, sixty, of Westholme Crescent, Masham, were familiar figures around the streets and lanes of the area.

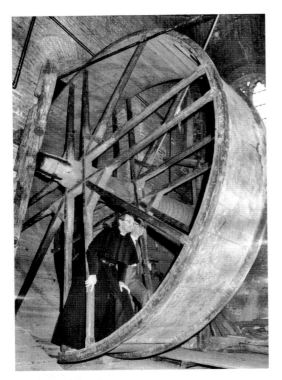 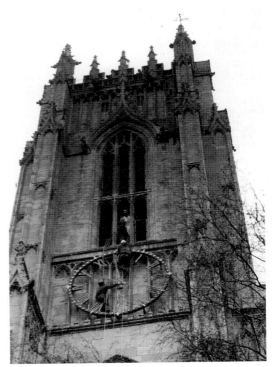

Above left: **Ecclesiastical**

'Church of England clergy do work hard, but this picture of the Rev Peter Harrison, Rural Dean at Beverley Minster, does rather overstate the case,' commented the *YEP* of 25 February 1976. Peter and a colleague were demonstrating the twelfth-century treadwheel crane in the central tower of the Minster, still used at that time for lifting building materials to and from ground level.

Above right: **Ecclesiastical**

The hands of time started moving again in Beverley during March 1993 following the successful completion of repair work to the Minster clock. Earlier in February, Beverley policeman Roy Roebuck and fellow climbing enthusiast Kevin Millington had removed the clock hands. Both objects were then taken to the BP chemicals plant at Saltend, where apprentice engineers undertook restoration work. The hands were regilded with gold leaf before being put back on the clock face. Head verger David Thornton said help from BP and the climbing experts had saved the Minster about £5,000. The picture shows climbers Roy Roebuck and Kevin Millington negotiating the north face of Beverley Minster in February 1993 to remove the clock hands.

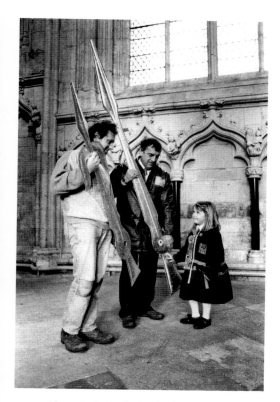 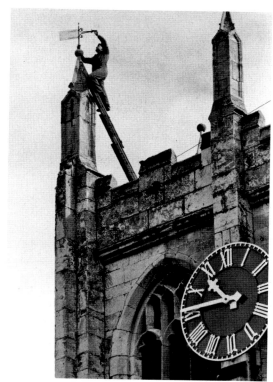

Above left: **Ecclesiastical**
Steeplekeeper Michael Robson and BP workshop supervisor Peter Smith hold the repaired hands of the Minster clock. With them is Amy Finch, six.

Above right: **Ecclesiastical**
A £3,000 renovation of Cottingham church near Hull was 'topped out' at the end of September 1987 with a 23-carat-gold weather vane. The delicate operation was carried out by Tony Krysiak, from the Leeds firm William Potts & Sons. The final touch followed repainting of the four clock faces in gold leaf.

Ecclesiastical

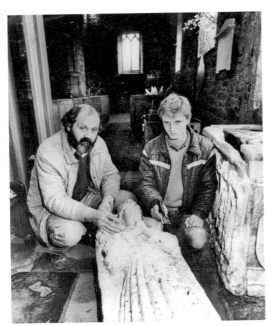

The *YP* of 17 May 1985 reported that the tomb of a royal prince, who died more than 500 years ago, had been restored at a North Yorkshire village church. Conservation experts dismantled the decorative monument of Edward, son of Richard III, and the last Plantagenet Prince of Wales, which stands in the parish church at Sheriff Hutton, near York. The alabaster tomb had become badly decayed and was restored by a Northamptonshire firm which specialised in conservation techniques. The tomb was damaged during the reign of the Tudors and had to be hidden away. It was discovered in 1824 covered in thick whitewash which was removed in the late nineteenth century. Paul Harrison (left) and Ian Crick are two of the specialists who restored the royal prince's tomb.

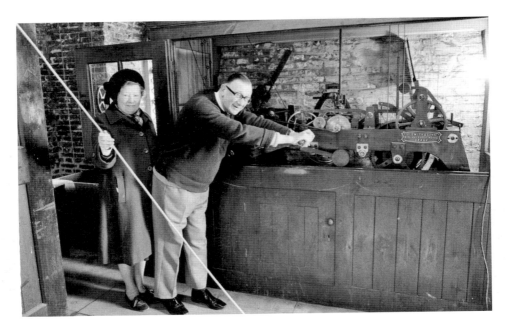

Ecclesiastical

In February 1983 it was predicted that Selby Abbey's clock would be taken over by an automatic device, replacing Bert Foster, sixty-eight, and his wife Irene, sixty-six, who had climbed 107 steps to the clock chamber to wind up the mechanisms every day for the previous four years. He was paid £1 per day. Selby Council was considering installing electric motors to wind the clock. Bert, a retired cashier, said, 'We tend to look at this philosophically. It had to come sooner or later.'

Ecclesiastical

In November 1974, the *YP* illustrated one of the oldest doors in the North of England as it was being x-rayed by experts to determine its age and, among other things, whether the iron figures on the twelfth-century woodwork were Adam and Eve or Noah and his wife. Peter Addyman, left, director of York Archaeological Trust, said that ironwork on the door at St Helen's church, Stillingfleet, near York, shows part of a Viking boat with steering oar and mast. It was hoped that x-ray photographs would identify lost nail patterns so that a complete picture of the original ironwork could be traced. The radiographers are Paul Fox and A. G. Stewart, foreground.

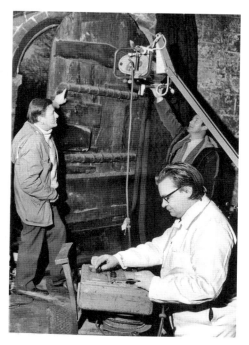

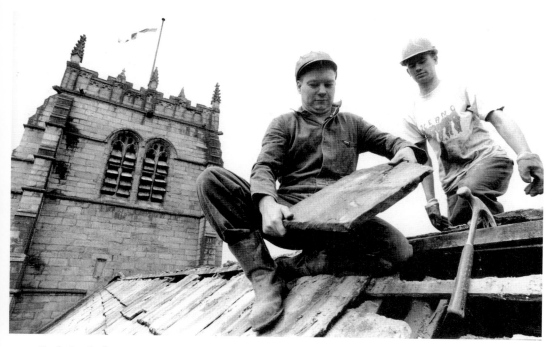

Ecclesiastical

Restoration work amounting to £500,000 got under way on Bradford Cathedral in May 1993. Crumbling stonework and the leaking roof were tackled by Andrew Waddington, left, and Ian Fenton, in the first phase of the repairs.

Egg Collectors

'Plundering sea birds' nests was not widely frowned upon in the old days when egg collectors raided [Bempton] cliffs in death-defying expeditions,' stated the *YP*. The men who braved the cliffs seem to have been regarded as heroes rather than villains. They would also be aware that contemporary guidebooks rated their activities a holiday attraction. Whilst the whole process sounds appallingly hazardous, visitors must have thought it one of the best free shows on earth: an open-air high-wire act without nets. The *YP* argued that here was no evidence that the harvest diminished the birds' enthusiasm for Bempton Cliffs, and although most folk today would frown upon the collectors' activities, few could dispute their courage.

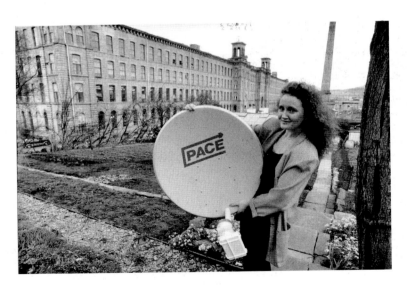

Electronics

An employee of Pace Micro Technology, Miss Debbie Hawcroft, displays one of the company's satellite dishes in front of the Victorian Salts Mill at Saltaire, which became the new home for the high-tech company in 1990. Pace was founded in 1982 by David Hood and Barry Rubery and from the original two partners employment had increased to 105 by 1990. 70 per cent of Pace's sales were to the satellite television market.

Electronics

Until 1995, when acquired by CINVen, the seven companies that went on to comprise the Advance International Group served formerly as the manufacturing division of Farnell Electronics plc. Three of those companies – Advance Power at Boroughbridge and Wetherby, Kelan circuits at Boroughbridge, and BBH Windings at Bishop Auckland – played a significant role in local northern economies, employing a combined workforce of 1,200. 'You will find our power energy systems operating in China, our ATE systems used by car manufacturers, and our rectifiers in the most sophisticated APBX systems in the world,' a spokesman told the *YP* in January 1996. The picture shows 'a special manufacturing cell' at Advance Power of Wetherby.

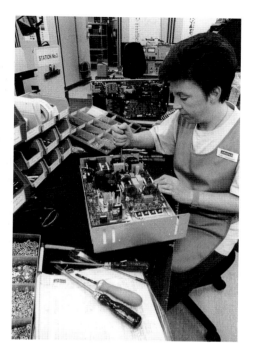

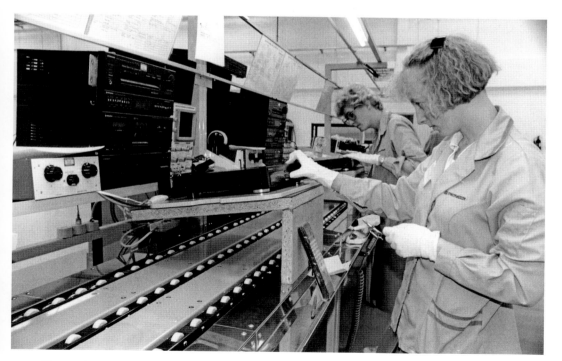

Electronics

In the Pioneer factory at Normanton, Tracy Winstanley gives a unit a final test on the production line in September 1991.

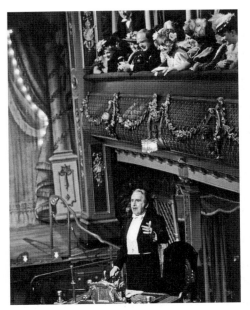

Entertainment
The inimitable Leonard Sachs is pictured at the City Varieties in Leeds *c.* 1983 performing in *The Good Old Days*, a popular BBC television light entertainment programme that ran from 1953 to 1983. It recreated an authentic atmosphere of the Victorian/Edwardian music hall with songs and sketches of the era performed by present-day performers in the style of the original artistes. The audience dressed in period costume and joined in the singing. The show was hosted by Leonard Sachs. In the course of its run it featured about 2,000 performers.

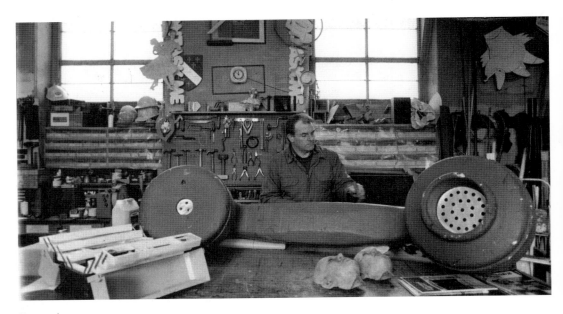

Entertainment
The *YEP* of 31 March 1989 revealed that blowing up buildings and shooting people was all in a day's work for the Leeds family firm Rowley Workshops, which provided special effects and models for television and film companies and had done for many years. 'Lately the head of the firm, 35-year-old, Ian Rowley, has been doing a convincing impersonation of the IRA for Scottish television which is filming new episodes of the detective series Taggart,' said the newspaper. For that job Ian, with trainee Tony Butler, was required to bring a number of buildings to an explosive end and also provide convincing bullet holes to both buildings and people during the shootout scenes.

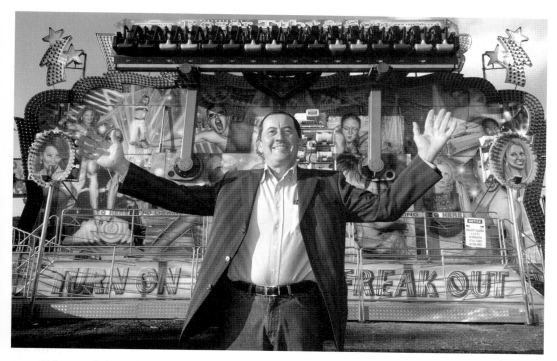

Fairground Organiser

On 8 February 2007 the *YP* said that the Valentine's Fair had arrived in Leeds for an action-packed sixteen-day visit. Roger Tuby, pictured, whose family had a long association with fairgrounds, was co-organiser alongside Stewart Robinson. Roger said, 'We always have a good time in Leeds, the people are great. And support from Leeds City Council is second to none.'

Fire Eater

When Michelle Northwood, pictured, left school, she probably never dreamed she would end up as a fire eater. The twenty-nine-year-old returned to her Leeds home in April 2003 after a decade touring with the Cottle & Austen Circus, performing in countries as far apart as Germany, Brazil and Japan. Michelle, a former pupil at the Notre Dame School in Leeds, spent several years as a dance and drama student before joining the circus, where she learnt the art of fire eating. She had also performed as an illusionist, dancer, ringmaster and knife-thrower's assistant.

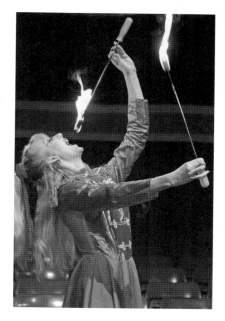

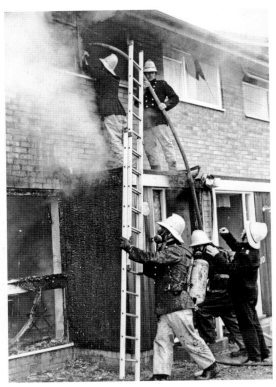

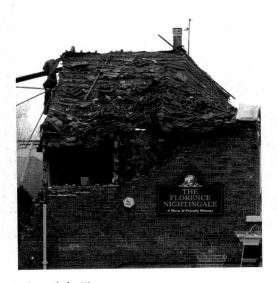

Above left: **Firemen**
In April 2008, a gas explosion ripped through the boarded-up Florence Nightingale pub in Beckett Street, Leeds. Five people suffered injuries. Firefighters are seen here examining the scene.

Above right: **Firemen**
Leeds firemen in action on 9 July 1975.

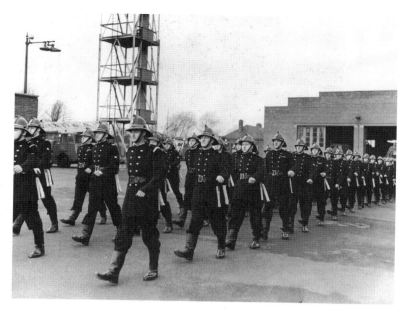

Firefighters

Men of Leeds City Fire Brigade are on the march after an inspection in October 1954 at Gipton fire station by HM Inspector of Fire Brigades, P. P. Booth. The *YP* was told that Booth had found the technical knowledge of the men to be very good and the standard of efficiency of the brigade high.

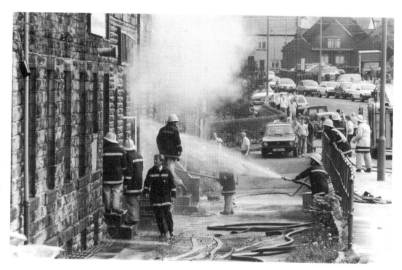

Firefighters

In May 1989, firefighters struggled to find water supplies as a huge blaze destroyed a factory and more than £1 million of stock. The fire broke out in Loxton lampshade manufacturers, Carlisle Road, Pudsey. The Pudsey fire station commander, Michael Brummit, said the brigade had been forced to call in two water-storage tanks, coincidently within a few hundred yards of the building.

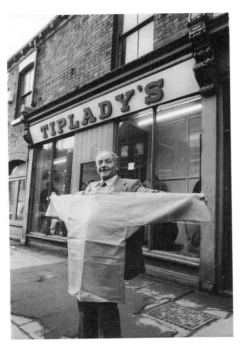

Fishermen's Outfitter

In December 1982, a Hull firm was to close after 100 years in business because of the decline in the local fishing industry. The seaman's outfitter's shop in West Dock Avenue, Hull, run by Mr George Tiplady, seen here with a traditional fisherman's smock, was to go out of business at the end of January. The business was started by Mr Tiplady's grandfather, Mr Henry Tiplady. The present owner, then sixty-nine, started working for the firm, which supplied all seaman's requirements to generations of Hull trawlermen, when he was fourteen. Mr Tiplady said that 'the fishing industry is nearly finished and it has badly affected business. Things are getting worse – it's all very disappointing.'

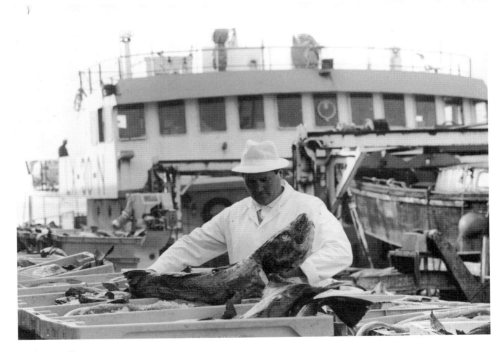

Fish Supplier

Hull fish merchant John Simpson examines supplies alongside the Portuguese factory ship *Sernache* in Albert Dock in February 1994.

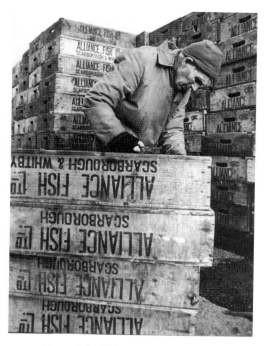

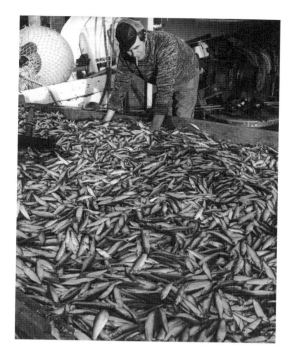

Above left: **Fish Box Repairer**

One of the oldest harbourside traditions at Scarborough – making and repairing fish boxes – was set to come to an end in early 1988 because of new European Community regulations. The head of Scarborough Fisherman's Selling Company said that at least two men would be out of work after years of repairing fish boxes for the fishing fleet. He added that fishermen were urging that the conversion to plastic boxes, costing them thousands of pounds, was done gradually, because the industry was already having a tough time due to the EEC's cutback of quota landings.

Above right: **Fisherman**

In February 1977, skipper Bob Mainprize is pictured aboard his 50-ton Scarborough keel boat, *Pathfinder*, with part of a record 100-ton haul of sprats, which he netted in two days. The sprats were used for cat food and fertilizer and the record catch was thought to be worth nearly £5,000.

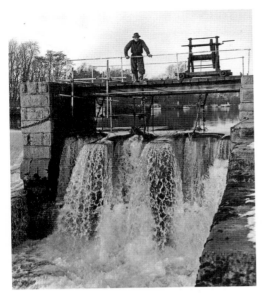

Flood Preventer
Mr William Elgey, a lock-keeper at Naburn Locks, sets the shutters at the side of the weir to lower the River Ouse and reduce the flood risk to York in January 1969.

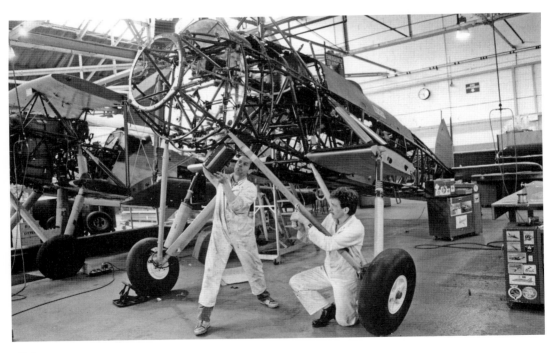

Flight
The *YP* of 14 May 1992 reported that a 1941 Swordfish warplane was being built by engineers at British Aerospace's plant at Brough, Humberside. A four-man team was working full-time under the direction of Graham Chisnall, director and chief engineer at the plant, to rebuild the plane, which was the oldest surviving model in the world. The process had been under way since December 1990, when the plane was transported to Brough in boxes from the Strathallen Museum in Scotland. BAE was restoring it for the Yeovilton Fleet Air Arm Museum.

Four

Food to Lion Tamer

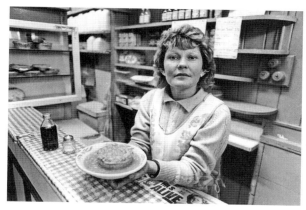

Food
Denise Saville with the pie 'n' peas her shop in Batley became famous for.

Food
In July 1988 a government training scheme job turned out to be the icing on the cake for one unemployed woman. Miss Julie Reynolds, twenty-one, of Scarborough, used to work in hotels, but subsequently realised her ambition to be a cake decorator. Julie's skills were brought out to such good effect on a training course that she landed a full-time job at the Scarborough cake shop Imaginative Icing, which specialised in unusual cakes. Julie said, 'I have always wanted to do this kind of work but it has only been made possible through the training scheme.' A spokesman for the Department of Employment said, 'Julie is a good example of how people can learn intricate and complex skills through the training scheme which has resulted in her securing a full-time job.'

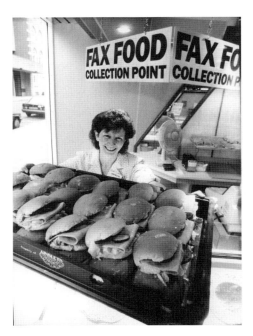

Food

'What does the Leeds yuppie eat for lunch?' the *YEP* asked in August 1989. 'Fax food of course' was the answer. Fax snax was the electronic lunch that was taking over in the bustling city centre scene. When the operator of a VDU needed a BLT (bacon, lettuce and tomato) he simply keyed in his culinary desire on the work's fax machine and picked it up later. It was the idea of the Leeds-based Ainsley's bakery, which the previous year celebrated its fiftieth anniversary. Two of its shops in the business heartland of Leeds, at Park Square and Park Place, had replaced the idea of fast food with fax food to serve their customers better. Veronica Thornham, manageress at Park Place, said, 'It's proving very popular because it's so convenient.'

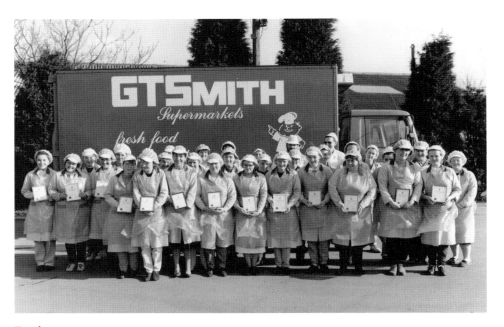

Food

The *YP* in March 1991 reported that throughout the fresh food factory belonging to Castelford's G. T. Smith, hygiene standards were meticulously observed. 'Most members of the staff have health and hygiene certificates and in that respect the firm is far ahead of any legislation,' said the newspaper. G. T. Smith's continuous policy was to ensure correct handling of foods and the firm had its own health and hygiene officer. Staff at G. T. Smith are seen here proudly displaying their Basic Food and Hygiene certificates.

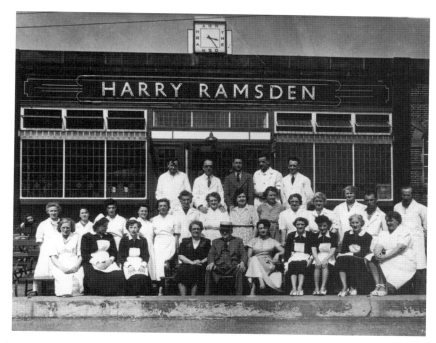

Food

The town of Guiseley near Leeds ground to a halt one night in July 1992, as thousands of people flocked to Harry Ramsden's fish and chip emporium. Portions were on sale for just 2p in a double celebration – the sixtieth anniversary of the opening of Ramsden's and the fortieth anniversary of the restaurant's entry in the Guinness Book of Records for serving more than 10,000 portions of fish and chips in one session. On that night in July 1992, 6,115 portions were served, with queues until midnight. First in line was eleven-year-old Johnathan Gadsby, pictured below with his sister Jenny being served his fish and chips by Harry Ramsden Jr. The picture above shows Harry Ramsden surrounded by his loyal band of helpers.

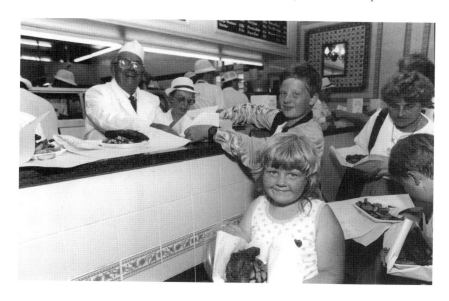

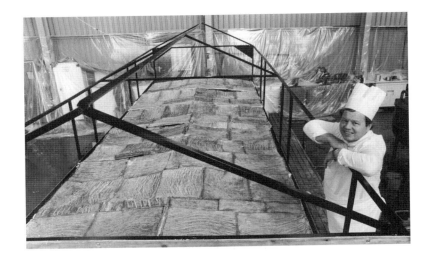

Food

Head chef Howard Gamble and his team of volunteers spent a whole night during September 1988 cooking a 7-ton meat-and-potato pie at a closely guarded barn in Upper Denby, in the foothills of the Pennines between Wakefield and Huddersfield. Environmental health officers supervised the cooking in several large specially built boilers. Then the pie was transferred to a 20-foot by 6-foot steel dish and its 60-lb flaky pastry crust was placed on top before it joined the festive procession from Scissett to the pie field on Denby Dale Road. The amazing pie was the ninth largest to be made in Denby Dale since records began. It contained three tons of beef, four tons of potatoes and half a ton of onions, seasoning and gravy.

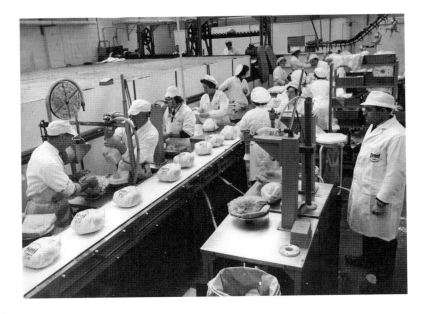

Food

The Twydale Turkey factory with Raymond Twiddle, right, watching part of the production line in November 1970.

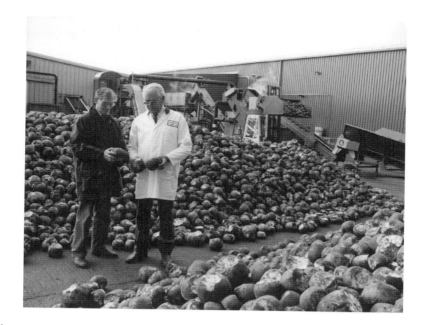

Food

Alan Barber, left, a Yorkshire farmer, discusses an incoming load of swede with Charles Berry, procurement manager with Fresh Country Foods of Goole in June 1988. The company was a major force in vegetable processing, freezing, packing and cold storage. Stephen McGrory, the company's managing director, said, 'Few companies invest in a procurement manager but there is no other way of making sure that the goods measure up to expectations. Mr Berry knows everything there is to know in this field.'

Food

The managing director of Wold Farm Foods, Michael Fort, right, and the factory production manager, Fraser Lyon, are watching peas being processed at the company's Grimsby factory in July 1980.

Furniture Maker

A furniture company founded in a garden shed in the early 1970s built, in June 1987, what was considered to be the biggest dining table in the world – and it needed Hull City Hall to do it. The table seated up to 250 diners in an E-shape measuring 17 m by 18 m. It was built by John D. Corlyon (Furniture) Ltd of Burstwick, near Hull, for a rich Middle Eastern client and was to take pride of place at a new palace. The order was completed in five months by the workforce, which had expanded over the years from a team of five to seventeen. The package also included thirty-five coffee tables with brass and marble tops and 24-carat-gold decoration. Mr Corlyon had to hire Hull City Hall for a couple of days; it was the only venue in the region with enough space to assemble the whole table.

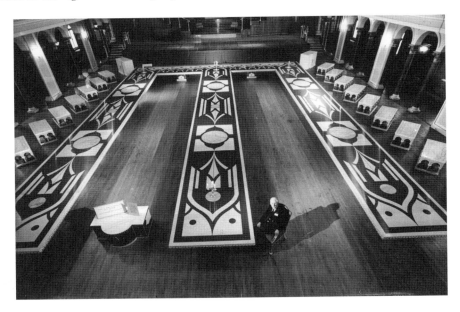

Right: **Furniture Maker**
'Their work may never feature in a 21st century version of the Antique Road Show, but members of the Ladderback Co-operative like to think they are doing their little bit for posterity,' said the *YP* of 25 September 1987.

Below: **Gamekeeper**
'Game keeping, once the preserve of middle-aged men, is starting to experience something of a feminine revolution,' said the *YP* of September 2010. Attending Bishop Burton College in East Yorkshire, twenty-year-old Ruth Lumley studied for a diploma in game keeping. There she learnt the basics of the job such as fence building, how to recognise different breeds of birds and animals, and also the all-important legal side of things, particularly what and when you can shoot. She was also taught the difference between legal and illegal traps. 'I was the only girl,' she said. 'I have hardly heard of any female gamekeepers at all. There are very few of us.' Since graduating, she worked for various estates in North Yorkshire before settling at Grewelthorpe in February 2010.

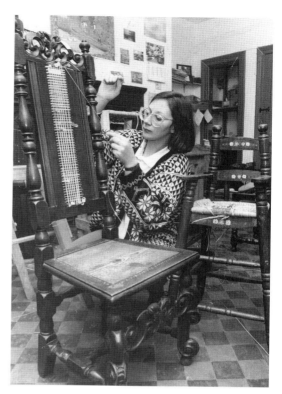

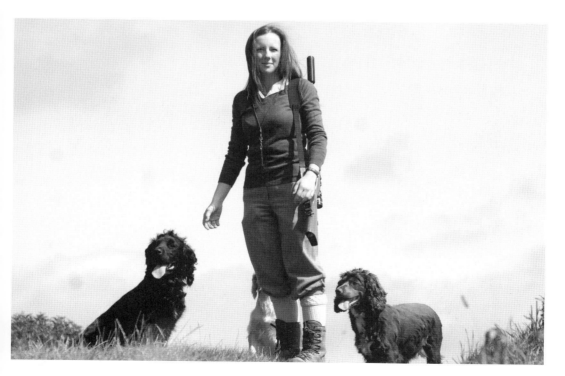

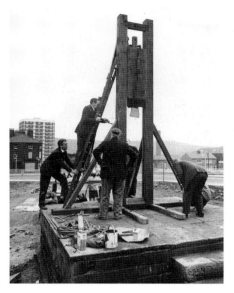

Gibbet Workers

During February 1974, final touches were put on the reconstruction of Halifax's famous gibbet, based on a description in the British Museum written before 1577. The instrument was erected on the original platform in Gibbet Street. In the reconstructed version the block and replica blade were bolted to the frame to guard against misuse. The last two executions occurred on 30 April 1650, after the victims were found guilty of stealing a length of Halifax kersey cloth and two colts.

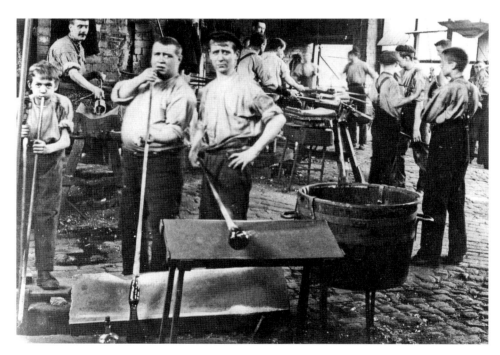

Glass Blowers

These are the glass blowers of Knottingley in the days when bottles were 'handmade' straight from the kiln. Before the introduction of machinery, hordes of men had the job of mouth-blowing the bottles into shape. This photograph of Bagley's Works in 1907 shows the conditions that once prevailed in the glass industry. The detailed photo was one of several presented to Knottingley Civic Society by the Bagley Veterans' Club when it disbanded after the factory's closure. Taken over by Jackson's Glass, the company eventually passed to Rockware.

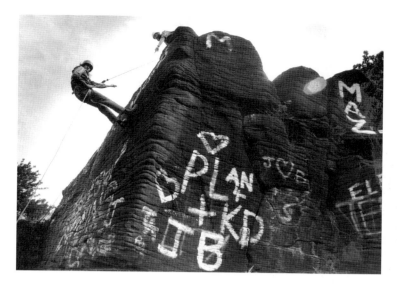

Graffiti Removers

Members of Bradford Council's anti-graffiti squad needed a head for heights – they regularly scaled walls and staircases at high-rise flats and council houses around the city. But in July 1990 when they turned their attention to the graffiti-scarred rocks above Valley Road, Shipley, they decided that a cool head was not enough. A squad of six men from the Graffiti Removal Unit at the council took three days' mountaineering training at the Cow and Calf Rocks, Ilkley, before tackling the scrawl on the 85-foot Shipley rocks.

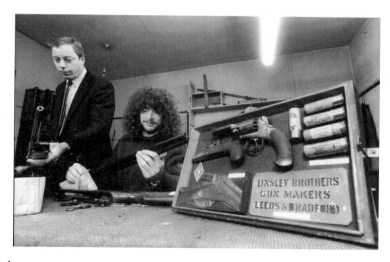

Gun Dealers

In October 1993 the senior manager of the Leeds gunsmith Linsley Bros, Duncan Teasdale, was taking a fond look round the workshop where guns had been repaired since the business opened in 1780. The shop in Kirkgate, which had served shooting and fishing enthusiasts for more than 200 years, was closing its doors and carrying on business at its Harrogate branch. Owner Barrie Davies said, 'We had to decide how best to run the business of Linsley's and we decided that the only way we could do that was to let the Leeds business go.'

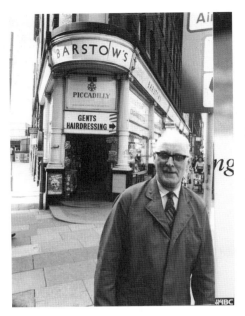

Hairdressing

A third-generation family business – in Leeds since the turn of the century – was to close its doors in June 1980 to make way for the bulldozers. The unique combination of confectionery, haircuts and chiropody at Barstow's, on the City Square corner of Wellington Street, was to end when half the block was demolished. The business was founded as a gentlemen's barber shop by Walter Barstow in the early 1900s and moved into its Wellington Street premises in 1910. Then the local businessmen could pop in for a shave for 4*d* or a haircut for 10p – a shilling on Saturdays.

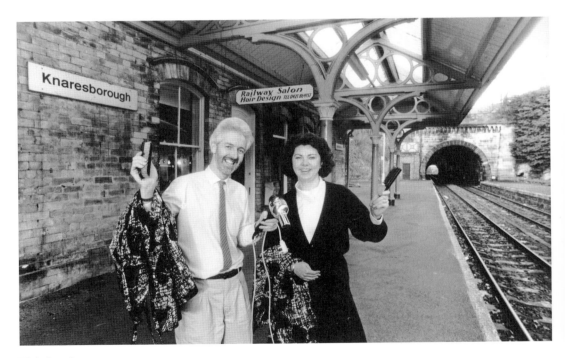

Hairdressing

'Train delays can now leave time for a short back and sides for railway travellers using a tiny North Yorkshire station,' said the *YEP* of 24 January 1990. The Railway Salon was the latest small shop to open for business on the platform at Knaresborough station. The unisex hairdresser's was run by Nick and Joy Burton, pictured, who had moved from the previous salon in Wetherby. The venture brought the number of shops at Knaresborough railway station to three.

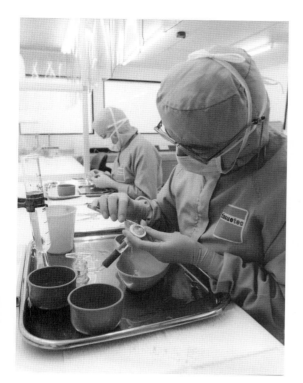

Above left: Heart Valve Makers
Workers at Tissuemed of Leeds, the British-owned manufacturer of porcine heart valves for surgical implants and one of the firms helped by the Small Firms Fund, in October 1992.

Above right: Heating Suppliers
Colin Cairns's job was to persuade the public to buy these ladies with the classical lines, but in August 1979 Leeds Council ordered them to be removed from Yorkshire Heating Supplies in Meanwood Road, Leeds. Colin was making the most of his place in the sun while the owners, John Brown Antiques, who used the YHS premises for displays, decided what to do.

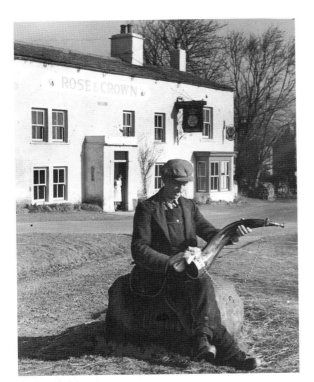

Above left and right: **Horn Blower**

The famous horn of Bainbridge (Wensleydale) gets a special clean and polish once a year, said the *YEP* of 16 March 1956. In the left picture, its blower, Jack (Jammie) Metcalf, takes advantage of a spring-like morning to sit on the 'throwing stone' on the village green and clean away before going to work. The custom of sounding three blasts on the horn at 9 p.m. was said to date from the days 'when Bainbridge was the Roman station of Bracchium and an evening horn recalled the legionaries to camp'.

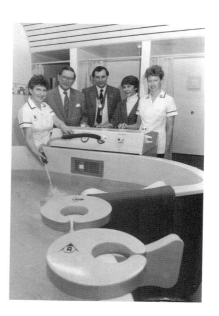

Hospital

The latest stage in the multimillion-pound redevelopment of Staincliffe General Hospital was unveiled in March 1986. Inspecting the new hydrotherapy pool in the child development centre were, from left to right: senior physiotherapist Annette Womersley; the Dewsbury Health Authority chairman Sam Lyles; the president of Spen Valley Lions, which provided equipment for the unit, Keith Ainley; a paediatric consultant, Gillian Wilson; and senior physiotherapist Teleri Robinson.

Horticulture

During May 1991, experts at Harlow Carr Botanical Gardens in Harrogate were hoping some of their flower power would help the people of Towyn, whose homes were devastated by coastal floods. Responding to a nationwide appeal for help, the Northern Horticultural Society prepared 3,000 packets of seeds, which they hoped would help once-inundated gardens bloom again. Professor Ivan Enoch said they were sending a wide range of plant seeds including bedding plants, shrubs, ferns and vegetables, but there was no guarantee that any would survive.

Hospital

The picture shows cryosurgery taking place on plantar warts at Huddersfield University's Department of Podiatry clinical unit. The *YP* of 12 June 1992 noted that the department was established in 1978 as a joint venture between Yorkshire Regional Health Authority and the then Polytechnic of Huddersfield. It was the first Department of Podiatry in the UK higher education sector. The clinical unit was recognised as a regional centre by the Health Authority and was equipped to a high standard, offering treatment to patients referred from within the Yorkshire region.

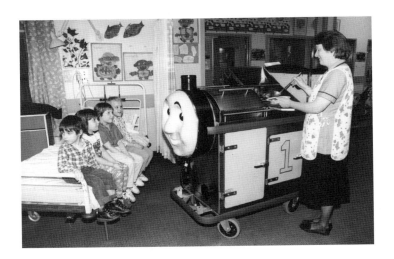

Hospital

During March 1993, play leader Brenda Gascoigne serves the children's ward at Harrogate General Hospital, with a little help from Thomas the Tank Engine. When the health trust bought food trolleys to meet new hygiene rules, children's character Thomas was taken onboard to give patients an added incentive to eat square meals.

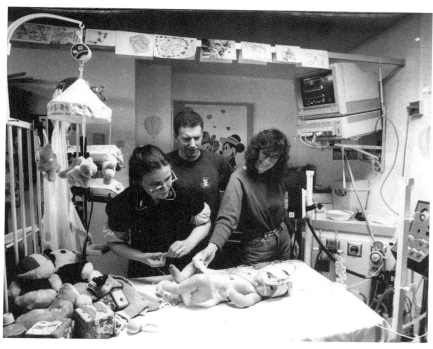

Hospital

Sister Doreen Spruce with John and Susan Staniforth and their baby, William, seven months, at the Sheffield Children's Hospital.

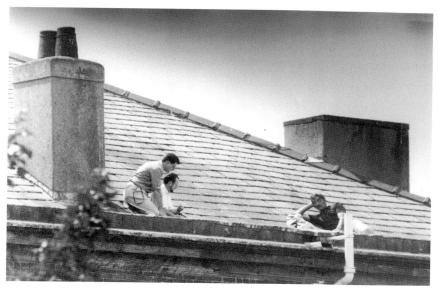

Hospital

Officials including a doctor and a policeman try to persuade a patient staging a rooftop protest to come down from the roof of Stockton Hall psychiatric hospital, near York, in June 1994.

 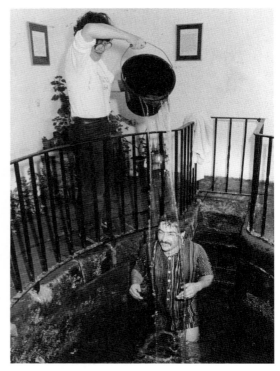

Above left: **Hotel and Catering**

Liz Smith, housekeeper at Harrogate's Majestic Hotel, won a hotel and catering 'Oscar', a coveted Catey, in July 1991. Winning a Catey – a bronze female – made Liz a household name in the hotel housekeeping world, and coming from the North made that distinction all the greater. But Liz was no stranger to success, having won numerous other awards during her career. Earlier in April 1991, she had picked up one of the 100 awards given by *Cosmopolitan* magazine to outstanding women. Catey award judges said Liz was an outstanding ambassador for the profession, managing people caringly, consistently and firmly attaining high standards driven by guests' needs.

Above right: **Hydro Spas**

Museum keeper Stephen Kerry tests spring water at one of Britain's oldest purpose-built hydro spas, White Wells, Ilkley Moor, during July 1983. He took the same cure as thousands of Victorians in water which had a constant temperature of 40 degrees Fahrenheit. Stephen, a keeper in archaeology for Bradford Museums and Art Galleries, was celebrating the reconnection of the spring water, said to cure a variety of ailments, to White Wells, which had two plunge baths. He said, 'It was so cold it took my breath away. It is a cure which I think would kill anyone who had a heart condition, but people can take the plunge if they want, by arrangement with us.' White Wells was built by Squire Middleton in the early eighteenth century. In 1973, it was renovated as a contribution to European Architectural Heritage Year by the late Eric Bushby who donated it to Bradford Council.

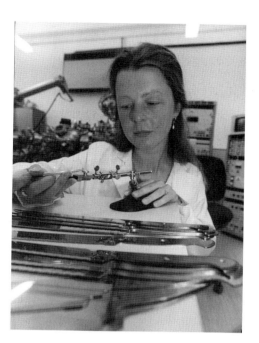

Knife Makers

Richardson's, Sheffield, the largest EU producer of kitchen knives, formed a £1 million partnership with the University of Sheffield in July 1994. Its aim was to develop a new generation of kitchen knives to ensure the continuance of the city's 700-year-old tradition as a high-quality knife-making centre. The picture shows a worker carrying out preliminary studies on the development.

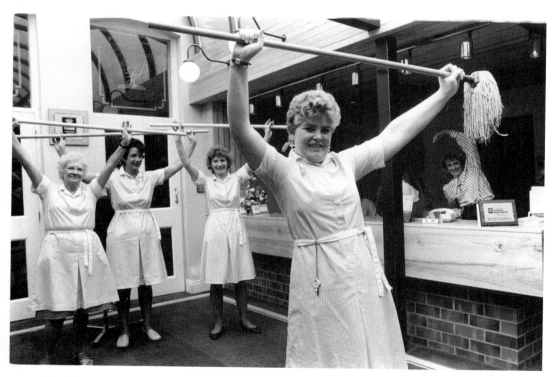

Keep Fit

Kerry Robinson heads the line-up of chambermaids keeping fit at the Grange Park Hotel, Willerby, under the supervision of Mrs Judy Salt in July 1987.

Knitting
Staff, builders and friends worked up to sixteen hours a day, seven days a week in a three-week period in June/July 1992 to prepare for the reopening of Worth Knitting in Wesley Road, Armley, Leeds. The building was wrecked in a fire that caused damage estimated at £400,000.

Librarian
Margot Beardsley, assistant in charge, and assistant Susan Merchant prepare the children's section at the new £850,000 Mexborough library before it was officially opened in Mexborough during January 1993. The premises in John Street, off High Street, were to house a stock of 22,000 books, audio and video cassettes, and compact discs in the main adult lending library, children's library and reference areas.

Lighthouse

In April 1986, Jim Deighton was putting his rock-climbing experience to good use. Jim, a bachelor, had moved into the disused Paull Lighthouse on the Humber in September 1985. And when spring cleaning was due he found his rock-climbing harness and ropes provided the best way of getting down to the job of painting the exterior walls. He was a member of the East Yorkshire Mountaineering Club and was more used to scaling peaks in North Wales and Scotland. Jim said, 'With the winds that blow across the Humber it's a lot safer doing it this way than by climbing a ladder.'

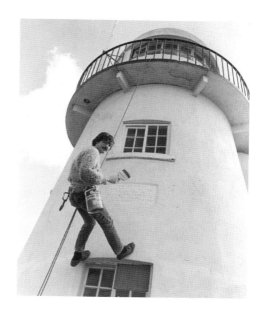

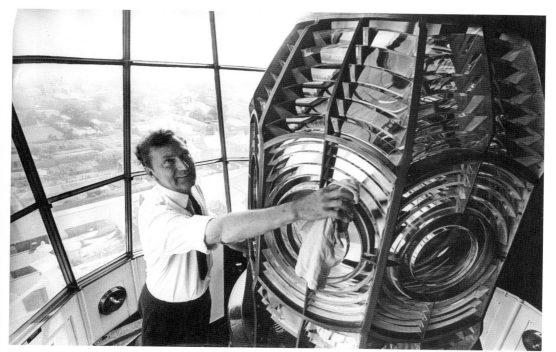

Lighthouse Keeper

Colin Nicholas, fifty-three, gives the lenses of Withernsea Lighthouse, North Humberside, a last polish before its final night of service. On 1 July 1976, Colin, the keeper at Withernsea for the previous four and a half years, closed down the eighty-four-year-old lighthouse. Trinity House decided that the light no longer served a useful purpose now that ships had sophisticated navigation aids. But the 140-foot building was to be kept as a daytime landmark for North Sea shipping.

Line Marker

Contractor Dennis Lee sets to work with his line-marking trolley on the streets of Kirkbymoorside in February 1992. Allegedly, it was the last town in England to escape the perils of yellow-line parking.

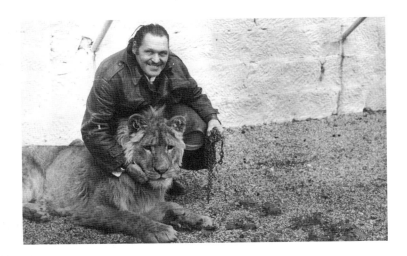

Lion Tamer

'Ever since Simba, the biggest lion in captivity in the world died in January [1973]', reported the *YEP* of 20 April 1973, 'his compound at Knaresborough Zoo, has been empty.' Other lions at the zoo – Satan, a youngster of about nine months, and Sullivan, a robust young lion of eighteen months – had been quartered in small enclosures. But with the opening of the zoo to the public at Easter, Nick Nyota, the curator, decided that Sullivan was ready to take over Simba's old den. But he would have to be walked on a chain the 75 yards from his home to the new quarters. So the zoo was closed to the public, all entrances locked, ponies, goats and other more domesticated animals nearby removed. Then Nick, clad in a heavy leather coat, riding breeches and boots, entered Sullivan's cage and with continuous encouraging talk, fixed one end of the chain round the lion's neck and the other to his wrist. The talk continued and after about twenty minutes and no real fuss, plus assistance from Barbara Nyoka and Raymond Tagg (sixteen), a trainee keeper, Sullivan was walked to his new home.

Five

Lock-Keeper to Prison Officer

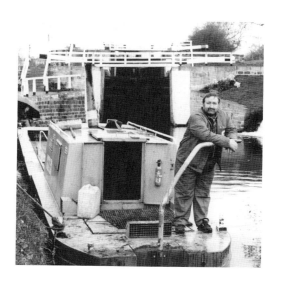

Lock-Keeper
Lock-keeper Gordon Knapton takes a break in November 1981 at the Dowley Gap locks on the Leeds–Liverpool Canal near Bingley. The lock won second place in a north-western regional British Waterways competition for well-kept canal locks and bridges.

Lovemaker
Lovemaking is a money maker for former teacher Ken Beachill, pictured, said the *YEP* in December 1991. His Condomania shop in Leeds Corn Exchange – the first of its type in the city – was helping red-faced males to enjoy safe sex. More than sixty brands of condom – from Scandanavia, the US, Germany, Holland and Spain – were on sale. Some even glowed in the dark. 'We are trying to change people's minds about condoms and remove the embarrassment of buying them,' said Ken.

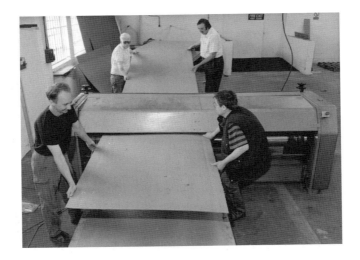

Manufacturers

In September 1989, Amalgamated Packaging's South Yorkshire connections based at Richmond Park Road, Handsworth, Sheffield and the Eastwood Trading Estate, Rotherham, operated as one unit under the control of general manager Keith Blackburn. With a workforce in excess of 200 people, the joint operation achieved a sales turnover of £3.7 million over the 1988/89 financial year. The Sheffield operation included specialist heavy-duty equipment that produced double- and triple-wall corrugated boxes designed for protection rather than transit. It also produced specialist packaging for egg producers. The Rotherham factory also had major facilities for the contract packaging business. The picture shows staff with an auto stitcher and a flexo printer article.

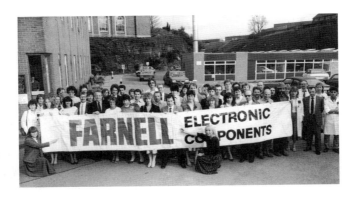

Manufacturers

A Leeds company launched in an attic with just £90 in 1937 announced in May 1985 record profits of £20.3 million and the figures put huge smiles on the faces of the 1,578 staff who were set to share in the bumper profit. They would each receive about £630. Managing Director Frank Wilson said, 'We are extremely pleased with the figures, which reflect the hard work everyone has put in. We have come a long way since those early days.' The business was started by Alan Farnell and Arthur Woffenden, who scraped together £90 and began selling radio components from a small attic near the centre of Leeds. Frank Wilson also added, 'I'm sure the profit-sharing scheme is another factor in our success. The money will obviously come as a boost to everyone and it makes the hard work worthwhile.'

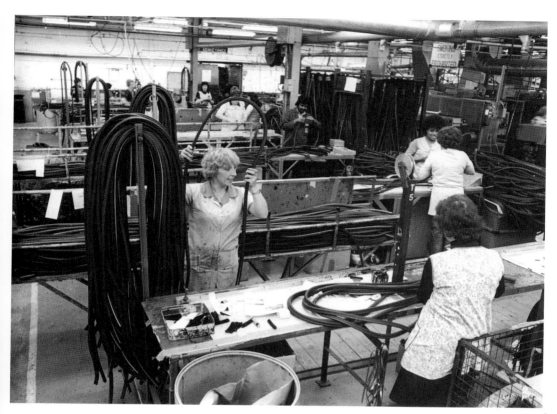

Manufacturers

'A thirty year anniversary is not a widely celebrated industrial achievement,' said the *YEP* on 2 July 1982. So why was Schlegel (UK) Ltd, making a splash about its first generation as a supplier of door seals to British manufacturers? Because, in the words of Schlegel's chairman Ian Herman, it marked the successful completion of a difficult era that had seen many automotive suppliers flounder and fall by the wayside.

Manufacturers

Lawrence Wilson & Son, of Guiseley, Leeds, manufacturers of 'luxury baby coaches', were celebrating ninety years in business reported the *YP* of 17 June 1967, adding, 'They are well aware that the demand created for their prams, folding push chairs and toy prams throughout this country, in Western Europe and in the United States must always be readily satisfied.' They used the latest in manufacturing techniques and equipment and the latest installation at the factory was the huge chromium plating plant seen here. It was the largest single installation Wilson's had ever carried out.

 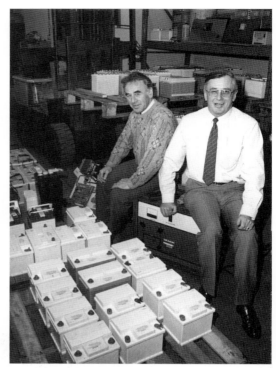

Above left: **Fence Building**

This picture, taken in March 1993, shows the fence-building family of May Wildsmith, sixty-six, and her daughters, Lynda Eller, thirty-five, and Pam Hague, forty-four, preparing an order for hundreds of feet of galvanised steel railings for the National Trust. The £17,000 contract was awarded to Wildsmith's of Hill Street, Sheffield, which was run by Mrs Wildsmith – widow of the firm's founder Ray – and Pam and Lynda. Every one of the 240 6-foot fence sections was made individually by the three women. Mrs Wildsmith and her daughters had no experience of business or fence-making when they took on the running of the company after Mr Wildsmith died in 1985.

Above right: **High-Powered**

John Owen (left) and his fellow director, David Pullins, with some of their batteries in 1990. The pair set up Sheffield's only independent battery company, Wyvern Batteries, after the firm for which they both worked ceased trading. Wyvern supplied all types of batteries from small ones for torches to huge industrial ones for forklift trucks and emergency lighting systems.

Market Traders

Market traders are busily at work on Leeds Kirkgate fruit market on Christmas Eve 1978. Leeds Kirkgate Market, located on Vicar Lane, is the largest covered market in Europe. There are currently 800 stalls which attract over 100,000 visitors a week.

Market Traders

Prince Charles chats to a greengrocer on Leeds Kirkgate Market whilst on a visit to the city in December 1975. In 1975, a fire had damaged much of the building except the Vicar Lane frontage, and the market was refurbished in the early 1990s. Following this refurbishment Kirkgate Market was upgraded from a Grade II to a Grade I listed building.

Market Traders

In February 1983 the storms brought an unexpected bonanza to shoppers in Leeds Market. More than 800 customers got the bargain of a lifetime when butcher Trevor Middleton, thinking his shops might be closed because of the damage to Leeds Market, cut his prices 'to the bone' and gave away vegetables with the meat. Mr Middleton, owner of two shops on butchers' row in the market, said, 'The row was closed at half past ten when a section of the roof came down. We could see it being closed all day – so we decided to sell off.' At the end of two and a half hours of frantic selling, Mr Middleton had sold about two tons of meat. Trevor Middleton (right) of Middleton Hargreaves butcher's is pictured with some of his staff who helped sell the meat; from left to right, Carol Hilton, Brian Longbottom, Christopher Farmer, Roy Marsden, Colin Clark, Jackie Morgan, Graham Wray.

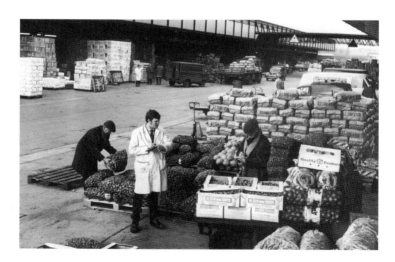

Market Traders

Retailers are gathered early one morning in February 1970 to buy their goods in the vegetable section at Leeds wholesale market. The *YP* of 26 February 1970 commented, 'Imported supplies come straight from the docks, and homegrown produce straight from the farm to the wholesale market on Pontefract Lane.' It was also mentioned that the city's Association of Fruit and Vegetable Wholesalers were embarking on the 1970s with a mission, and that was to convince the public that processed goods cannot, and will not, ever be a complete healthy substitute for fresh food.

Merchant and Royal Navy

Teenager Lisa-Marie Hannam set sail into unchartered waters in September 1993 as she became the first female pupil at an historic all-male naval school. Earlier in the year the sixteen-year-old passed her GCSEs to take her place at the Trinity House School in Hull, where pupils received a normal secondary education while training to go into the Merchant and Royal Navies. Smartly uniformed and peak-capped, the pupils had all been boys since the 206-year-old school was founded in the city's Old Town beside Princess Dock.

Maze Chairman

Farmer Ted Harland inspects an ancient Roman maze at Alkborough, which had to shut down in November 1991 because it had become too popular with tourists. Mr Harland, sixty-four, chairman of the five-man maze committee, said, 'About a year ago the Council declared it an ancient monument and put up signs directing people to it ... So many people have walked round it that the paths have started to wear away. We had to close it down and get a landscape gardener in to look after it. People will still be able to look at it but they will not be able to walk round it.'

Military

'If the Russians press the button and send nuclear warheads to devastate the West, a top security station [Fylingdales] on the North Yorkshire Moors will be the first to know,' reported the *YP* in October 1979. The RAF installation, costing £45 million, of which £36 million was contributed by the USA, was guarded by Ministry of Defence police. At that time, three 140-foot-diameter domes protected giant radars. But the nerve centre was the tactical operations room beneath the centre dome. There the team of RAF personnel worked sixteen-hour shifts, keeping a constant watch on the computer as it instructed the radars to scan space and track any object that was not immediately identifiable. The picture shows part of the operation room at Fylingdales.

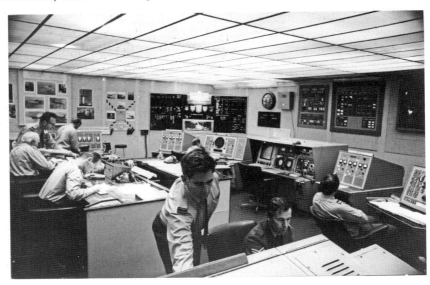

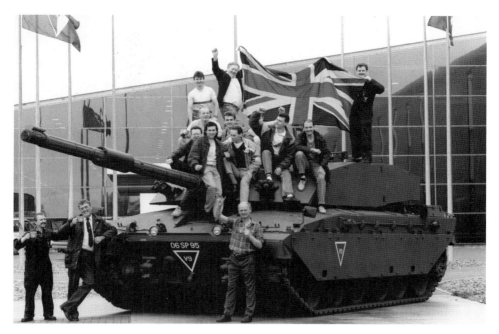

Military

Workers at Vickers Defence Systems, Leeds, worked round the clock early in 1991 to supply the Gulf Forces. 'We are physically shattered,' said vehicle tester Brian Shann. 'But we keep going for the lads. Their need is much greater than ours. Their lives could be in our hands.' Vickers built the Challenger I tank, which played a key role in the ground manoeuvres. They also produced recovery vehicles and provided specialist engineers to give technical support. The pictures show workers at Vickers with Challenger tanks.

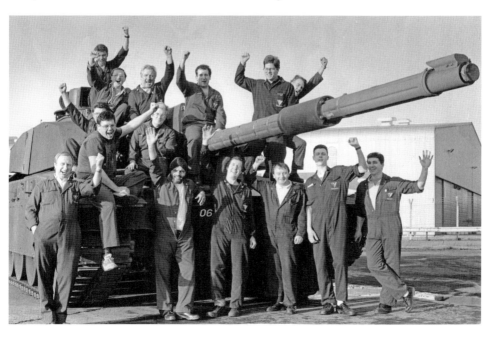

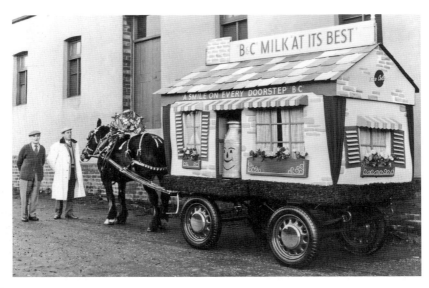

Milk Men

A Brightside & Carbrook decorated horse-drawn milk float pictured on Easter Monday, 15 April 1963.

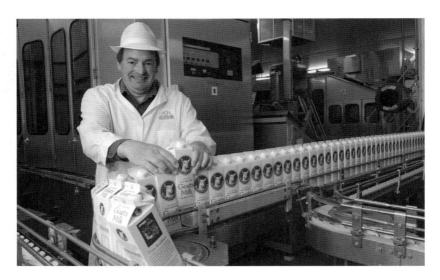

Milk Man

On 11 October 2010 the *YP* reported that Angus Wielkopolski had beaten off tough competition to become the first ever non-cow's milk farmer to be highly commended in the Dairy Farmer of the Year awards. The newspaper added, 'Angus, owner of St Helen's Farm at Seaton Ross, near York – the UK's largest producer of goats' milk and dairy products – was shortlisted as one of the top three finalists at the 2010 Farmers' Weekly Awards. The farm is the only major goats' milk supplier to use 100 per cent British goats' milk, and makes a range of butter, cheese, cream, milk and yoghurt from 10 million litres of milk a year. It supplies 40,000 customers including Tesco and Sainsbury.' Angus said, 'It shows that goats' milk is now being taken seriously at all levels.'

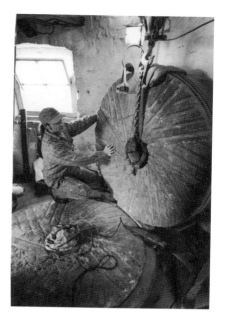

Millers

Millwright Steven Boulton is seen carrying out restoration work on grinding stones at Skidby Mill, near Hull, in November 1993. The millstones were being given a new lease of life, so that wheat at the windmill could be ground for years to come. Specialist craftsmen were 'roughing up' the surfaces, which, over the years, had become too smooth. Peter Colley, Beverley Borough Council's economic and tourism officer, said, 'Roughing them up is an extremely long process.'

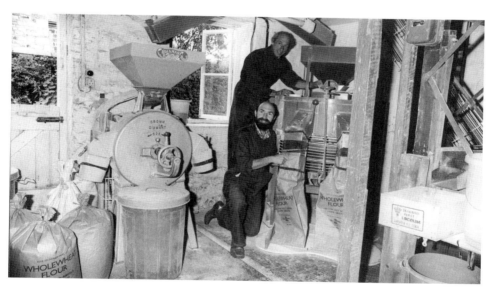

Millers

The *YEP* of 11 August 1982 reported that business was booming for Yorkshire's own dusty miller. His mill was in a converted stable in the back garden of his Thorner Leeds home. But it was too small to cater for the increasing demand and he was looking to expand. At that time three tons of grain was milled, packed and delivered each week by just Mr England and his son Timothy. Their speciality was organically grown wholemeal flour, which was eagerly snapped up by wholefood shops not only in Leeds but as far north as Durham and, going south, Buxton. 'It is because people are becoming more educated in what they should eat. Junk food is out,' explained Mr England, who began his business in 1976 when he should have been planning his retirement.

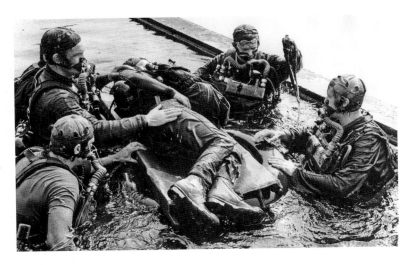

Mine Rescuers

Members of the Mines Rescue Service are seen carrying out a practice rescue in a reservoir at Walton Colliery, near Wakefield, in July 1975. 'The Lofthouse disaster [of March 1973] showed up the necessity for men to familiarize themselves with workings in almost sub-aqua conditions,' a National Coal Board spokesman said. 'The men have been training in swimming baths and the exercise in the reservoir, which is now becoming part of standard training, is to make it more life-like.'

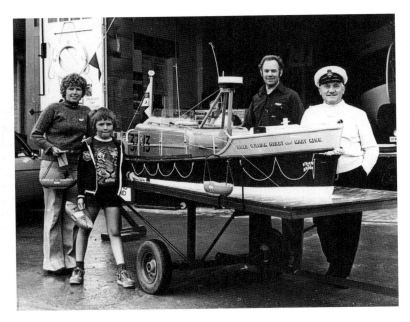

Model Makers

A model way of collecting money was used on the annual Flag Day at Bridlington in August 1979. A model of the resort's lifeboat, *William Henry and Mary King*, was used as a 'collection box'. The model was made by Fred Walkington (second right) and Dennis Atkin (right). Also in the picture is Mrs Walkington with son Grant.

Model Makers

A giant model of fourteenth-century Scarborough was the resort's latest tourist attraction, said the *YP* of 13 July 1977. The 12-foot by 7-foot model, made by archaeologist and expert model-maker Peter Farmer, a local man, was to go on display later in the month to mark the Queen's Silver Jubilee. Months of research, locally and in the British Museum, went into the model. Many of the timbered houses were based on the style of those in the Shambles at York. Built at a cost of £1,700, raised by public subscription, the model had a scale of one inch to 27 feet.

Music Maker

Manager John Gillot is pictured in the showroom of Wood's new music shop in Street Lane, Roundhay, Leeds, in August 1986. Robert Wood, managing director of the Wood's music shop chain said, 'It is an important move and one we have wanted to do for some time. Leeds has always been a hole in the map as far as we have been concerned and now we have filled it.' He also stressed members of their expert staff were on hand to assist customers with their purchases, from the selection of make and finish right through to maintenance and care. John Gillot had many years of experience in piano and organ retailing. He was a knowledgeable teacher/musician and an able demonstrator of all the varied keyboard technology.'

Noise Detective

On 11 December 1973, the *YP* ran a story about Leeds Councillors' decision to introduce decibel detectors at venues where live music was amplified. They fixed a level of 93 decibels and reached this decision after studying an impressively documented report by Ronald Fearn, a lecturer at Leeds Polytechnic. 'Leeds' decibel level just won't work,' said Alan Wallis, director of Castle Associates, Scarborough, a firm making equipment that cut off a group's amplifiers when a pre-set sound level was reached. 'It is a question of compromise between possible hearing damage and what the audience finds acceptable,' he added. In the photograph, model Jennie Dukes poses with a noise detective.

Organ Grinder

Michelle Ibbitson, three, of Shadwell, Leeds, turns the handle of a seventy-year-old barrel organ with the help of its owner Dennis Todd. In March 1972, he loaned the organ to Leeds Playhouse for the lunchtime presentation of Robert Pinget's *The Old Tune*. It was built in Leeds by Tomasso Brothers.

Paint Makers

Taken in January 1978, this picture shows staff on one of the filling lines where hundreds of litre tins were filled with Home Charm paints every hour at the Silver Paint & Lacquer Company's factory at Batley. From a very small family-run business the company had grown into the large and professional SPL Group of Companies, employing hundreds of people in the Batley and Morley areas. And from a turnover of £12,000 in 1947, the company grew until its turnover exceeded £12 million in 1977.

Parksmen

'It was warm work,' reported the *YEP* on 28 June 1975, 'so up went the sleeves for the Bradford Parks men who had created the summer showpiece in Lister Park.' More than 16,000 plants made up the floral clock, which had the 100-year-old Royal Society of St George as its theme.

Pickle Makers

Shaw's Pickles of Huddersfield was one of the region's businesses to benefit from the marketing consultancy package of the Enterprise Initiative in September 1989. This was the umbrella help on offer to businesses from the Department of Trade and Industry – the so-called 'Department of Enterprise'. Taking advantage of the scheme, Shaw's, Yorkshire's largest independent pickle and relish manufacturer, asked for marketing consultancy as the company realised its sales and marketing functions lacked direction. As a result, Shaw's appointed a second sales manager to cover the home market, created a corporate image, improved its sales documentation and provided training for sales staff.

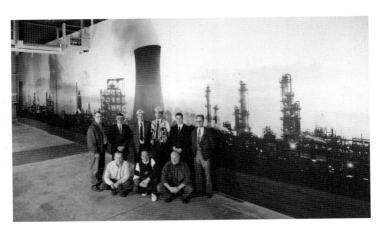

Photographers

Staff members of the Brighouse specialist photographic laboratory, A. H. Leach, are pictured in 1993 with a 75-foot-long photographic blow-up for BP Chemicals. At the time it was one of the largest photographic prints ever produced. The picture was made from three 5-inch by 4-inch transparencies, which were used to make inter-negatives from which prints were enlarged in thirty 8-foot by 5-foot sections. The picture was to be used in a new visitor centre.

Policemen

In January 2011, British Transport Police and members from Network Rail were undertaking a day of action, targeting cable theft from railway lines in the Castleford area. The awareness day was to highlight the extreme dangers and to ask members of the public to report suspicious activity in their area. Pictured is British Transport Police dog handler PC John Hawkins with 'Riot', checking the line for any suspicious activity.

Poet

Poetry in motion at Bradford Industrial Museum in May 1993 as Ron Bairstow treated visitors to a rendition of Yorkshire dialect poetry – with actions – recalling wash days past. The reading was part of a celebration of the lives of older people.

Postcard Makers

A workers' co-operative was going from strength to strength in February 1993 thanks to the vision of a political activist. Leeds Postcards had been running for fifteen years and produced 'alternative' postcards for the labour and trades union movement and campaign groups. It had produced more than 10 million postcards, which circulated all over the world. The company was originally set up by Richard Scott as a one-person operation based in one room in Burley, Leeds. In the photograph Christine Hankinson, left, and Alison Sheldon show some of the cards.

Post Office Worker

'No one can fail to find the Post Office at Terrington, North Yorkshire,' said the *YP* in February 1970. Standing by the hedge, on which grew the living sign, is Charles Farmer. When he moved into the post office from York in 1963, he let the hedge in front of the shop grow and then trimmed it to form the letters. During the previous year, the village won an award of merit in a best-kept village contest.

Pottery

The wheel turned full circle for Paul and Shirley Mazza in July 1990. The owners of Horsforth Pottery met at the town's Trinity & All Saints College some twenty years earlier and, after a detour to Slaithwaite, near Huddersfield, they returned twelve years later – by accident not design. The former linesman's cottage at Horsforth station became available as a workshop for Paul. At first he travelled each day from Slaithwaite, spending long hours monitoring gas and electric kilns. But then the Mazzas moved in to live over the shop in the stationmaster's house.

Postman

On their trek over the North Yorkshire Moors near Goathland in April 1965, the postman and his dog pass the cluster of cottages at Darnholm.

Prison Officer

The long, bare galleries of a wing in Wakefield Prison in July 1960, each floor separated by safety netting, under the eye of a watchful prison officer. The *YP* of 18 July 1960 reported, 'The secure perimeter holds within it more than 600 men sentenced to corrective training including Star prisoners (men having their first taste of gaol), those who have been sentenced to death and reprieved, lifers and young prisoners who have been given long sentences for notorious crimes.'

Prison Doctor

Dr Peter Smith Moorhouse supervises a hypnotherapy session for alcoholics at Wakefield Prison, helped by Joseph Kaveney, prison hospital principal officer (right), in March 1971.

Six

Rag-and-Bone Man to Windmills

Rag-and-Bone Man
The small man with the horse and cart plays just as vital a role in the scrap metal business as the top bracket merchant who can install sophisticated machinery, said the *YP* in January 1969, adding, 'They form a chain in which every link is vital – and what happens at the end of that chain leaves no room for doubt about the importance of scrap.'

Restaurant Chef
Chef Agus Sabagio, in the pub-cum-Indonesian restaurant at the Ash Tree, Sowerby Bridge. After a visit there, Robert Cockroft wrote in the *YP* of 23 February 1988 that the Ash Tree's owner once ran the aircraft catering for Indonesian Airlines for sixteen years. His wife was Indonesian, and so was their nephew, the chef, who is pictured here. 'The place, to judge by the car park attracts high-fliers, people who like to make a night of the set meals, for say eight people: 13 different dishes from Rendang Daging to Oseng Oseng,' chirped Cockroft.

Restaurant Owner

In the autumn of 1987, *YP* readers were asked to sing the praises of their favourite Indian restaurant in the first part of the newspaper's 'Restaurant of the Year' competition. There were a number of strong contenders but the winning review, selected by *YP* food writer Robert Cockroft, was submitted by David Wood of Huddersfield. He won a dinner for two at his nominated restaurant, the Aagrah in Shipley. For the restaurant there was a plaque to commemorate the award. Pictured with it is Mohammed Sabir (right) along with members of staff. Mohammed is also seen working in the kitchens.

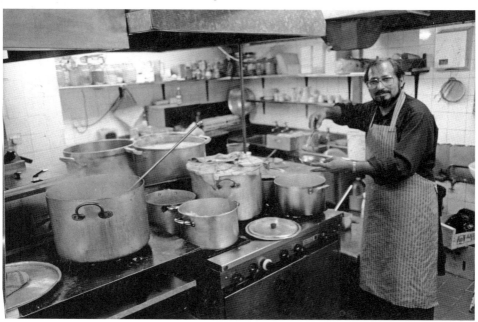

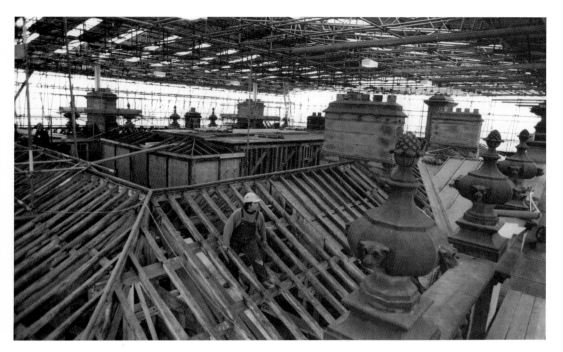

Restorers
English Heritage Commissioner Roger Suddards (above) inspects reroofing that was under way at Harewood House in December 1993. The Earl of Harewood is seen in the picture below. The Harewood House Trust had received a major award by English Heritage amounting to a 40 per cent contribution towards the £700,000 cost of the work.

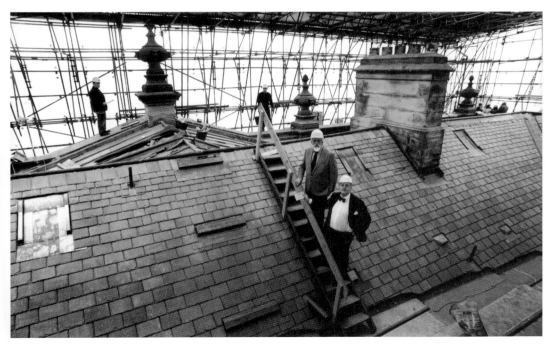

Restorers

Late in 1993, bosses at Harewood House were awarded a European Community grant to restore the historic building and gardens. This meant that the flower beds and box hedgings removed from the terrace at the front of the house would be restored after being abandoned in 1959. More than 200 horticultural students from Askham Bryan College, York, were to carry out the work, which would include lifting turf and planting beds and hedges in order to restore the gardens to the original plan by Sir Charles Barry in 1844.

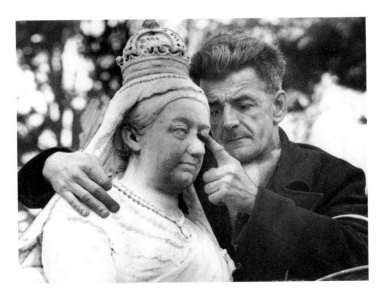

Restorers

During March 1970, Queen Victoria's white marble statue in York's West Bank Park was given a new nose to replace the one broken off by hooligans several months earlier. Laurence Martin, a mason in the Ancient Monuments Section of York Corporation's Engineer's Department, who carved the new nose, is seen here performing the transplant operation. Walter Slater, Inspector of Ancient Monuments at York, explained, 'It has taken quite a time to fit a new nose and we had to make sure that it was exactly right. We studied photographs of Queen Victoria.'

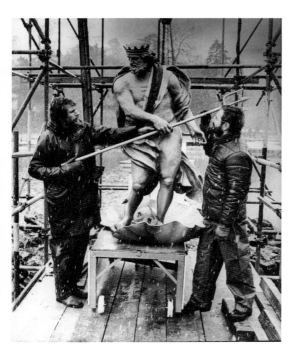 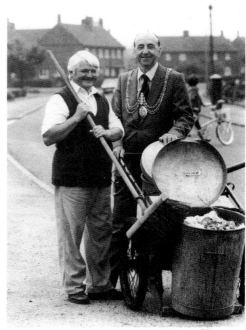

Above left: **Restorers**

In 1985, the lead statue of Neptune standing in the moon pond at Studley Royal was removed for a £15,000 facelift. Neptune, one of three lead statues at Studley Royal attributed to the eighteenth-century craftsman Andrew Carpenter, was restored by Naylor Conservation, a Shropshire company specialising in garden sculpture. The 15-cwt statue is pictured on 8 April 1986 when an attempt to rehouse it had to be abandoned due to rain and snow making lifting operations hazardous. Yet, in time, the task was completed.

Above right: **Roadsweeper**

In July 1983, road sweeper Ben Railton was ready to crown his thirty-year career with a visit to Buckingham Palace. Ben's chance came when the Mayor of Beverley, Cllr Harry Flynn, received three double tickets for a Royal Garden Party. 'Normally the Mayor goes along to the Palace with councillors who haven't been before, but I wanted to do something to show the council workers how their efforts are appreciated,' said the Mayor. 'And I chose Ben because he takes a real pride in his job and has done since he started 30 years ago.' Ben commented, 'I'm certainly looking forward to [the occasion]. Neither I nor my wife have ever been to London.'

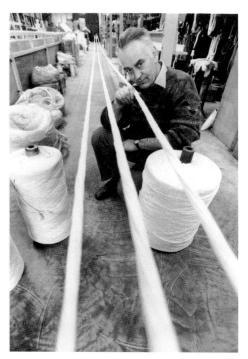

Rope Makers
In May 1993, Peter Annison, of Hawes rope makers W. R. Outhwaite & Son, had a novel target for the year 2000 – he wanted to help Britain become self-sufficient in candle wick. The firm was carrying out final tests in its Station Yard premises before starting production of candle wick – the type that went in candles rather than on bedspreads. Peter, who ran the business with his wife Ruth, said just two manufacturers produced wick, with the rest imported from the Continent.

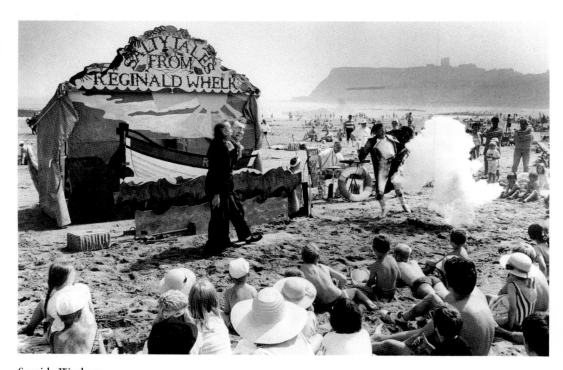

Seaside Workers
A theatrical show on Scarborough beach in July 1991 has onlookers enthralled.

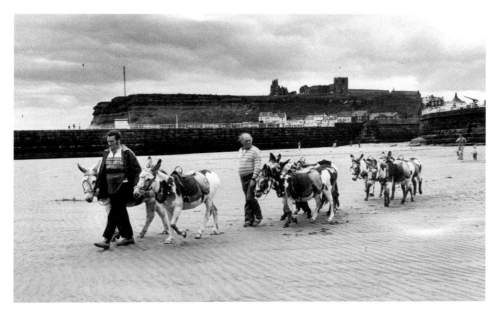

Seaside Workers

A caption on the reverse of this picture dating from July 1991 reads, 'Bad business for the beach donkeys ... With the poor weather and recession not many people are holidaying leading to a quiet life for the traders trying to make a living on Whitby beach, pictured Rodney Shaw (left) and George Cockburn.'

Pond Warriors

Pictured in June 1991, these two men – Bernard Schofield, fifty-eight, and Malcolm Walker, forty-six – had been involved with the spectacular, twice-weekly battles every summer at Peasholm Park, Scarborough, since the 1950s. Working for the local council, they had an intricate task of using electrical currents to explode at least 250 charges in each battle with pinpoint accuracy and timing.

Seaside Worker

The *YP* of 16 February 1980 reported that maintaining Whitby's 199 church stairs, which link Abbey, church and town, was for many years a task as steep as the historic steps themselves. An appeal was launched in 1980 to save the stone stairs, which had fallen into disrepair. Church officials, who had insufficient funds, said the restoration would cost thousands of pounds. Day-to-day maintenance was done by George Storr, seventy-one (left), a churchwarden, Jack Hinter, seventy-nine, and Harry Louth, seventy, who pointed the stones, repaired the railings and swept the stairs from top to bottom to get rid of the rubbish visitors strew. Historians may care to note that the steps were originally wooden ones, supported on stilts, and date back to 1318.

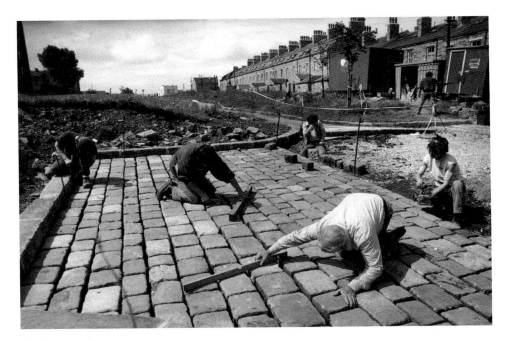

Sett Layers

During July and August 1987, a traditional Bradford street was being recreated to add a touch of romance to the everyday life of city-centre office workers. Setts and Yorkshire stone flags were being laid in a century-old street once lined with small cottages, which had been demolished ten years earlier. Money to rebuild council-owned Victoria Street, off Manningham Lane, Bradford, was given by a property developer, Harry Clough, who owned the main office block overlooking the street, which was used by the Department of Health & Social Security. The picture shows chargehand Stanley Taylor levelling up the setts put down by members of the Bradford Project team in Victoria Street.

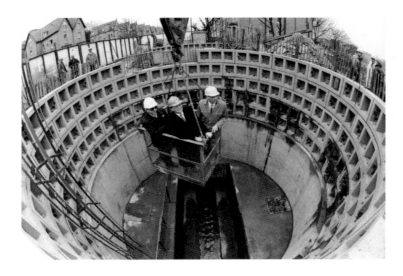

Sewer Inspectors

Bradford city engineer John Knight (right) inspects progress on a scheme to replace the city's crumbling sewer system in March 1993. He is accompanied by Fred Parkinson, of civil engineers DCT, and John Walker (left) of Yorkshire Water. They were taking a close look at a newly completed section near North Avenue, Manningham. The work, a partnership between the council and Yorkshire Water, was part of a multimillion-pound improvements programme known as the Bradford Basin Sewerage Strategy.

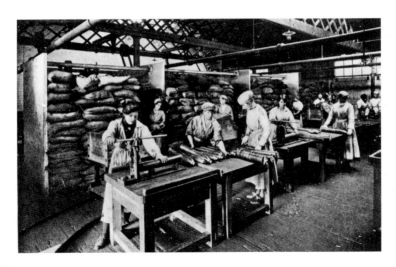

Shell Fillers/Fusers

The worst tragedy that Leeds ever knew – in terms of people killed – never made the headlines, reported the *YEP* on 16 March 1973. The dreadful explosion that killed thirty-five women and girls occurred at the Barnhow Munition Factory, Cross Gates, in the First World War. It was not until six years after the war that the public were told the bare facts for the first time. Most of the workers were women, drawn from a 20-mile radius. The majority came from Leeds, but York, Selby, Harrogate, Wakefield, Tadcaster and Wetherby all provided a big quota. The picture shows a Shell Fusing and Indenting Room at Barnhow.

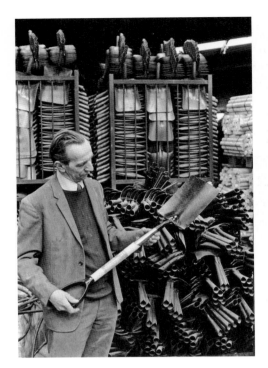 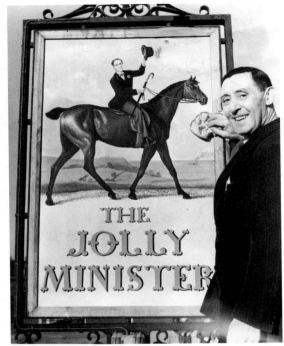

Above left: **Shovel Makers**

Shovel manufacturers Richard Carter Ltd, of Kirkburton, near Huddersfield, celebrated their 250th anniversary in 1990. The company began by making hay spades in a blacksmith's forge at High Burton, a short distance away, in 1740. Shovelmaking began when the firm moved to Kirkburton a century later, and the output in 1990 was approximately 125,000 per year. Ten years earlier, coal and steel took three quarters of their production but as those industries declined new markets among builders' merchants and horticulturalists were found. Carter's had supplied round mouth and pan shovels to miners in Nova Scotia and loco shovels to railwaymen in Australia and New Zealand.

Above right: **Sign Painter**

During late 1955, thirty-three-year-old artist Claud Harrison was commissioned to paint the inn sign for Northallerton's newest hotel, the Jolly Minister. The bespectacled, moustached features of the rider, who is elegantly clad in formal morning dress, were those of Food and Agriculture Minister Derrick Heathcoat-Amory. Claud's instructions came from brewery director, Douglas Nicholson, after the Minister had commented on the choice of inn signs, and mentioned the link between agriculture and brewing at a dinner. Landlord James Doyle said, 'The customers think the sign is wonderful and all praise it.' A plaque was to be fixed inside the hotel to explain the origin of the sign and name.

Snuff Makers
Worker at Wilson's & Co. (Sharrow) Ltd, Snuff Mills, Sheffield, in December 1981. The company's website states that the first Wilson to go to Sharrow Mills was Thomas, a shearsmith, who rented the water wheel and buildings from the Duke of Norfolk in 1737. Seven generations of the Wilson family have followed Thomas at Sharrow Mills and the business is still wholly owned and run by members of the Wilson family.

Spinners
These Gomersal workers were flying high in December 1988 after their firm became the first worsted spinners in the country to be allowed to display the British Standards Institute kitemark seal of quality on its goods. After exhaustive inspections by the Institute's independent assessors, it was agreed that the knitting yarns produced by Thomas Burnley & Sons met all the requirements of international controls. Technical manager Keith Newland is pictured centre with fellow workers. Employing 500 hands, the firm produced up to 200 tons of spun worsted yarn every week for use by manufacturers of knitted garments.

Stage Set Designers

In May 1991, members of Hangar Services, theatre scenery specialists based at the former wartime aerodrome in Tockwith, near Wetherby, were working on a £200,000 contract for Classical Productions' ambitious staging of the opera *Tosca*. With the scale model of the stage set are draughtsman Peter Sargent, left, and construction manager, Andy Chelton. The *YEP* of 17 May added, 'A huge 20-foot door dominates the scene as miniature carpenters scurry around like tiny ants clutching hammers and chisels; outside a giant's altar stands in splendid isolation, waiting. It's a bizarre, almost surreal, setting where average-sized men and women are dwarfed by the sheer scale of their surroundings.' The newspaper also informed readers that the opera was to include the largest pieces of scenery to be built in Britain during that year.

Steel Makers

Pictured in December 1993, Ken Bradley, left, and Paul Shutt, inspect steel wire at Tinsley Wire, Sheffield, which converted thick steel rods into everything from shopping trolleys to staples.

Steel Makers
Interior view of Forgemasters,
Sheffield, in March 1995.

Stone Mason
'Occupying equal pride of place
with a Henry Moore figure
at Castleford's Civic Centre
will be a piece of sculpture
by another Castleford man
– the Corporation's 57-year-old
Highways Department Supt. Mr
Sam Bailey,' reported the *YEP*
on 22 December 1965. Sam,
by trade a bricklayer-mason,
carved the borough coat of
arms in hard York stone from
a Brighouse quarry. He is seen
here working on the coat of
arms in a corner of a small
garage at the Corporation's
Highways Depot by the light of
a single electric bulb. It took him
around six months to complete.
Castleford Corporation accepted
the work from Sam and the
architects planned to incorporate
it over the main portals of the
Civic Centre.

Stuntmen
One of the spectacular attractions at the annual Leeds Gala held in Roundhay Park in August 1981 involved members of Earl Majors' stunt team flying through flaming hoops.

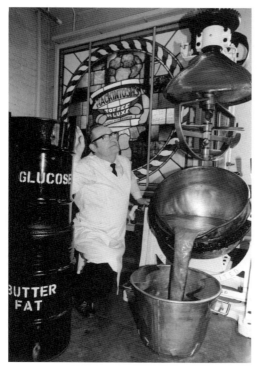

Toffee Maker
During January 1991, the caretaker of the Calderdale Industrial Museum in Halifax, Geoff Greenwood, checks the quality of the toffee from the boiler, which was once part of the Mackintosh factory. The boiler was part of an exhibition called Sweet Dreams featuring artefacts and samples from the Halifax factory.

Town Crier

The *YEP* of 13 May 1988 mentioned that seventy-four-year-old Sid Bradley was looking back with satisfaction over his first month as Knaresborough Town Crier. He had borrowed his apparel from the Doncaster Town Crier but within a fortnight was hoping to have full regalia of his own with the backing of Knaresborough Chamber of Trade, which sponsored him to promote the town. He said, 'I took the job because I don't want things to change. I don't want Knaresborough to be a load of offices and pubs. I want to retain the shops where you can get personal service.' Sid was born in Starbeck and became an architectural pupil as a young man in Knaresborough. He was with the Ministry of Works in Leeds from 1947 until he retired when he was sixty-four.

Toll Men

'The champagne corks might be popping on September 19 [1991] to celebrate the first free crossing of the River Ouse in Selby, but there will be no party for the men who collect the tolls,' announced the *YP* in August 1991. Amongst those who feared for their future was Michael Hampshire, pictured, who had given more than twenty-five years' service to the private company which was about to hand over ownership – and he made his point felt during a recent visit by former Transport Secretary Cecil Parkinson. As Parkinson crossed the bridge to see the traffic hold-ups for himself it was Michael who made a defiant gesture on behalf of himself and his colleagues by holding out his cap as a begging bowl.

Theatre Worker
The play officer from the Hull-based Remould Theatre Company, Ruth Curtis shows off a couple of the specially designed corn sculptures, used as props in the play *Reap the Whirlwind*. The story centred around Snowden Dunhill, a local rogue/corn thief who was twice sentenced to deportation to Australia. The play was staged at Howden's Senior School in February 1988. Remould was the professional organiser of the play, which featured a cast of more than 200 drawn from the local community.

Train Driver
Arriva train driver Pauline Cawood of Morley, Leeds, pictured at York station in December 2001. At that time she was one of around a dozen women driving trains for the company.

Train Driver
Loco driver Ron Hoffman in the cab of his diesel-electric locomotive in October 1977.

Undertakers
Ian Haigh is pictured in the Chapel of Rest at undertaker's Wm Dodgson & Son, Leeds. The company's website states they have been 'in business helping families in Leeds and surrounding areas since 1842' and that they are 'family-orientated funeral directors of distinction'.

Undertakers

Adrian Benson of Benson's Funeral Directors, Beeston, Leeds, is pictured with a woollen coffin in January 2010. He contributed comments to a *YEP* article of 25 January 2010 that discussed the shortage of grave space in Leeds. His comments were: 'More people are cremated today than are buried and there are a number of reasons why. People tend to follow what relatives have done previously. Another factor is cost. It's a lot cheaper to be cremated. For a typical burial, you are talking about £3,500, whereas cremation will cost you about £2,400, depending on what you have. I am aware that the council is trying to buy back land to make more grave space. At the end of the day, councils will always do that. Funeral costs have risen recently and part of that must be the acquisition of new land.'

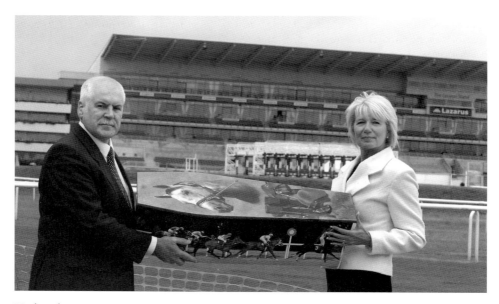

Undertakers

Funeral director Jeff Allsop with Respect Green Burial Park's Alison Finch and a horse-racing-themed coffin, which they displayed at Doncaster Racecourse during the St Leger Race meeting in September 2011. Respect's boss Gordon Tulley said, 'We take the samples when we go to hospitals and hospices to talk about the sort of burials we do.' He added that everyone grieves in a different way and any design can potentially be put on the side of coffins.

Underwater Equipment Suppliers

During February 1988, Slingsby Engineering of Kirkbymoorside, world leaders in the design and production of underwater equipment, introduced an amazing robotic arm. Designed chiefly as a Mrs Mopp to reach into subsea nooks and crannies on oil rigs and platforms, it could also carry out a range of tasks at more than twice the depth of the wreck of the *Titanic*. Chief robotics engineer Andrew Taylor is pictured here with his creation, which was called the TA-33 nine-function Master/Slave Manipulator. He said that it was a challenge to design and build something more dexterous than the human arm and which could reach round and into things at great depth. He added that the TA-33, equipped with camera and lights, would be used to clean marine growth from subsea structures of oil rigs and platforms with powerful water jet and rotary brush attachments.

Warehouse Manager

Bob Robinson, the on-site manager of Leeds' Regent Street Skillion mini-warehouse, shows one of the storage units in December 1987. It was run by Bob and his assistant Andrea McClaren. Bob said, 'Essentially it is a do-it-yourself operation, a drive in facility with customers using their own or hired transport which we can arrange. However, we do provide lifting and handling equipment, plus of course the 24 hour security system.' The *YP* of 18 December 1987 said that the warehouse brought the US concept of mini-warehousing to Leeds for the first time.

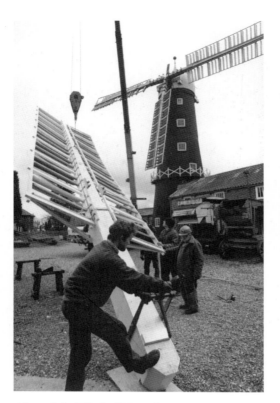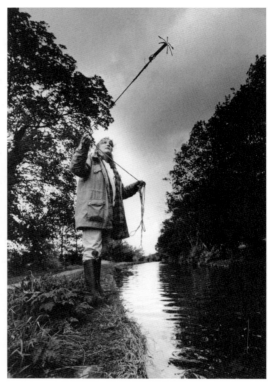

Above left: **Windmill Repairers**
The *YEP* of 5 January 1979 stated that Skidby Mill was perhaps the last complete working town mill east of the Pennines and north of the Humber. The mill was owned by Beverley Borough Council and had called in R. Thompson & Son millwrights to carry out extensive renovations.

Above right: **Waterways Surveyor**
A student, Beatrix Richards, searches the bed of the Leeds–Liverpool Canal with a hook, looking for rare plants during October 1990. It was part of a British Waterways survey of aquatic and waterside plants on a stretch of the canal at Riddleston, near Keighley. The 1½-mile stretch was to be drained for important repairs to cure a long-term leak and BW did not want to destroy special plants. Any rare species discovered by the team led by BW's Jonathan Briggs were to be removed to a safe site and returned when the repair work was complete. BW's regional manager, David Blackburn, said that plants were a valued part of the canal environment.